Hemingway's
HAVANA

Also by Robert Wheeler

Hemingway's Paris:
A Writer's City in Words and Images

Hemingway's
HAVANA

A REFLECTION OF
THE WRITER'S LIFE IN CUBA

Robert Wheeler

With a Foreword by
América Fuentes

Skyhorse Publishing

First Edition

Skyhorse Publishing books may be purchased in bulk at special discounts for sales promotion, corporate gifts, fund-raising, or educational purposes. Special editions can also be created to specifications. For details, contact the Special Sales Department, Skyhorse Publishing, 307 West 36th Street, 11th Floor, New York, NY 10018 or info@skyhorsepublishing.com.

Skyhorse® and Skyhorse Publishing® are registered trademarks of Skyhorse Publishing, Inc.®, a Delaware corporation.

Visit our website at www.skyhorsepublishing.com.
Visit the author's site at www.facebook.com/robertwheelerauthor/.

10 9 8 7 6 5 4 3 2

Library of Congress Cataloging-in-Publication Data

Names: Wheeler, Robert, 1963– author.
Title: Hemingway's Havana : a reflection of the writer's life in Cuba / Robert Wheeler.
Description: New York : Skyhorse Publishing, [2018]
Identifiers: LCCN 2017046291 (print) | LCCN 2017046417 (ebook) | ISBN 9781510732667 (ebook) | ISBN 9781510732650 (hardcover : alk. paper)
Subjects: LCSH: Hemingway, Ernest, 1899–1961–Homes and haunt–Cuba. | Hemingway, Ernest, 1899–1961–Knowledge–Cuba. | Authors, American–20th Century–Biography. | Americans–Cub–Biography. | Cuba–Description and travel.
Classification: LCC PS3515.E37 (ebook) | LCC PS3515.E37 Z945 2018 (print) | DDC 813/.52 [B]–dc23
LC record available at https://lccn.loc.gov/2017046291

Cover design by Erin Seaward-Hiatt
Cover photo by Robert Wheeler

Printed in China

Para Meme . . . mi inspiradora. Sólo quiero decirte una vez más: aquí estoy para ti. Hoy te amo más que ayer.

For Meme . . . my inspirer. I just want you to know that I am here for you. Today, I love you more than yesterday.

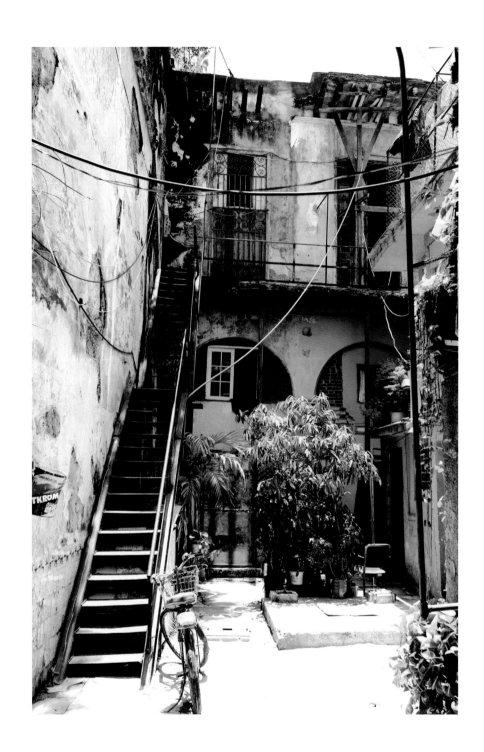

Contents

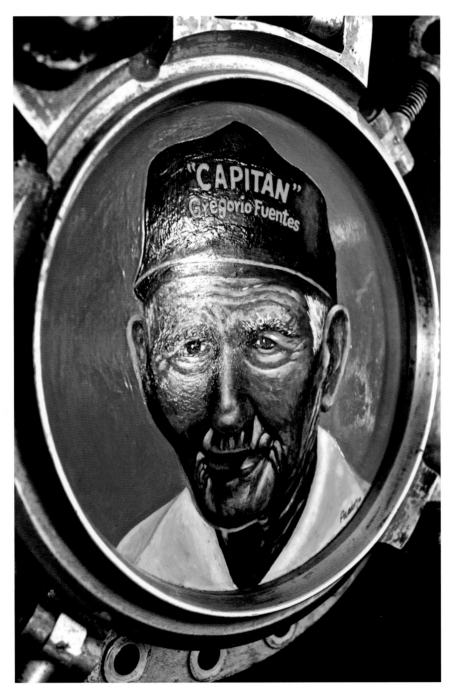

He would rather fish than eat or sleep.

Foreword

By América Fuentes
Translated from the Spanish by Carla Estrada

My grandfather, Gregorio Fuentes, met Ernest Hemingway in the Dry Tortugas. They were both staying there to protect themselves from an oncoming storm. My grandfather helped Hemingway make a phone call to the States to let people know he was not lost and was safe. Thankful for his help, Hemingway promised that he would find my grandfather and see him in Cuba one day. Hemingway kept his promise, came to Cuba, and looked for six months, but did not find him. Then one day, someone placed a call to Hemingway and told him that Gregorio was on shore and that Hemingway could meet him. Hemingway left immediately for this specific reason. They met–ate, drank, and spoke– and Hemingway proposed that Gregorio become the captain of his boat, the *Pilar*. From that time, to the day Hemingway died, they were forever together.

For me, the presence of Hemingway in my village and at my house daily was so normal that I never saw him as a famous person. He was like part of my family, and we treated him like a member of my family. The thing that I liked, and loved, about the friendship of my grandfather and Hemingway was the genuineness and passion and the dedication and affection they both shared of the sea. The experience and knowledge my grandfather had about the secrets of the sea impressed Hemingway. My grandfather often said that, always, he would do whatever the sea expected of him.

Something else they shared in common was how a man should be . . . how he must live. A man must be friendly and honest, and simple and humble, and have a sense of solidarity. In their eyes, men had to possess these traits to be real men and to be counted. Hemingway and my grandfather—they were not just about the sea but also about how a man must behave in the world.

Both Hemingway and my grandfather took Cuba as their second home. My grandfather was from Spain, the Canary Islands. He came to Cuba very young in a boat from Spain as a hired cabin boy. When the boat came into the bay of Havana, he jumped over the rail and into the water, swam away from the boat, and hid himself in Casablanca. This is the way my grandfather came to Cuba—a man out of the sea. But always, Hemingway and my grandfather felt the draw and the enormous passion of Cuba, and they both embraced the people and their particularities.

When people come to Cuba, and to my village, Cojimar, and think of my grandfather and of Hemingway, I hope they should make this toast to the legacy of these two men . . . it is a toast that contains significant meaning in Spanish: *We delight in these two men, two men who lived por el mar, y para el mar.* The best that I can translate is that Hemingway and my grandfather lived because the sea exists, and lived as servants to the sea.

Please enjoy this intimate book by Robert Wheeler, as his words and photographs have given an honest and clear picture of the

Hemingway that my grandfather loved, and of the Hemingway that we Cubans—especially the fishermen from Cojimar who want his memory to remain alive—still hold dear.

Some believe the name *Habana* is derived from Middle Dutch, *havene*,
meaning "haven" or "harbor."

Preface

All I have written was inspired and formed during a thirty-seven-day stay in and around Havana in the hot months of July and August, 2015. Having a slight understanding of the Spanish language, and listening constantly to the rhythms of the language spoken all around me, my English–like that of Hemingway's when he lived in Cuba–changed. The combination of two languages to achieve meaning formed a new and significant lingua franca.

Throughout my editing process, and that of my publisher, the decision was made–in the spirit of authenticity–to keep these fresh nuances in language. If one is lucky enough to reach below the surface of Cuba, that person will understand this decision, and this transformation in thought and language will be theirs as they set forth to discover Hemingway's, and their very own, Cuba.

Thank you for this courtesy . . .

<div align="right">Roberto</div>

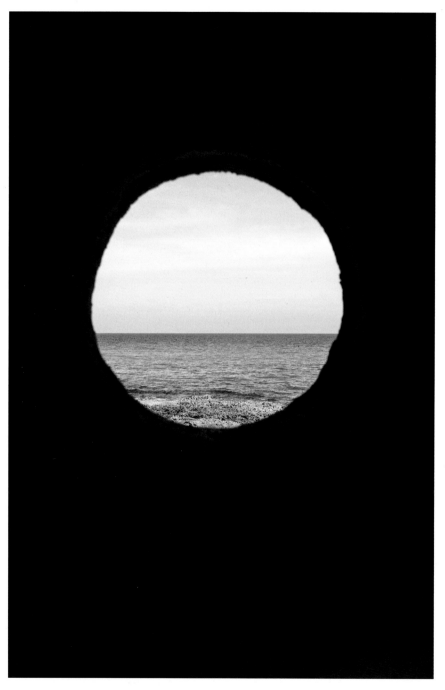

All I wanted was to know that I experienced a small and lovely glimpse.

Introduction

In discovering Cuba, Ernest Hemingway found his most lasting, and most true, home. Having learned and loved along the boulevards and within the gardens and cafés of Paris, Hemingway was looking, once again, for an inspiring and lovely setting in which to write and live. From the moment that he set his eyes on this small island nation, encircled in blue, Hemingway knew that, unlike Paris, he would never leave.

Because of the poignant and deep complexity that existed, and still to this day exists, between Hemingway and Cuba, I knew I had to let go and allow the people, and the island itself, to teach me the story I needed to write. Just as Santiago, Hemingway's "old man" who fished alone out in the deep sea, used his experience and instinct to hook his great brother, the marlin, it was imperative for me during my stay in Cuba to see and reach beyond academic research and tourist clichés and to use my knowledge and intuition to land this portrait of Ernest Hemingway. Each word and each punctuation mark I wrote, and each photograph I took, had to mirror the profound sense of serenity, enrichment, and community that Hemingway found in Cuba. In this spirit, within are my interpretive reflections on the thoughts, feelings, and actions of a man torn by love, loyalty, frailty, and the brevity of life.

So . . . here is Cuba—The Sea, The Land, The Work, and The Visit—revealed as closely as possible through the eyes and spirit of Hemingway himself. Here is the island, a proud and resilient nation that embraced an American writer as one of their very own. Through prose and photographs, I hope it is easy to understand why Hemingway once shouted with resolve and conviction, "I am Cuban, after all."

1

The sea green masterpiece—

—and the blue sea . . . both weathered by Nature's hand.

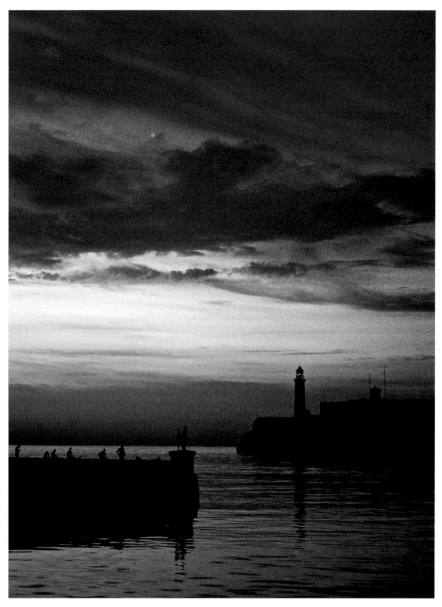

A symphony of color and of interaction plays each evening.

The Sea

Ernest Hemingway came to Cuba from the sea, due south across the clean and blue Florida Straits from Key West. The year was 1934, and he motored into Havana Harbor–past the 200-foot rise of the stone Fortaleza de San Carlos de la Cabaña and Morro Lighthouse–aboard his new and prized fishing boat, *Pilar*. What he immediately saw and felt was so very different than most Americans who flew into Havana's airport or yachted into the many fancy marinas. On the long and winding Malecón and along the palm-treed shoreline, Hemingway saw life–a people naturally absorbed in the reflections of the sea made by the intense colors of the setting sun. It was clear that these Cubans were living *por el mar, y para el mar*, and doing so with grace and in harmony. First impressions counted greatly to Hemingway, and Havana's honest and subtle splendor is what filled his senses as his boat slowly and softly moved into the welcoming and protective Havana Harbor.

Nowhere in all of Havana do the sun and city and the sea and stars come together more beautifully than along the Malecón, Havana's Balcony. Lovers, no matter their age, stroll along and sit upon this winding stone wall. Romantic liaisons between young lovers . . . married couples escaping the heat and activity of a cramped and shared apartment within the city . . . older couples reflecting on a life lived . . . children playing while talking about their day—this is indeed a place of energy, hope, reflection, and joy. Hemingway would walk along the Malecón and feel the bluish-green sea push its weight against it while thinking about stories written and those still to write. He would often sit, taking out a small notepad, and write. He would write of the direction of the wind, the strength of the current, and what the colors of the sea looked like with the fading sun. Hemingway was a romantic, and he was an Imagist poet, and he lived what he wrote and wrote what his eyes saw.

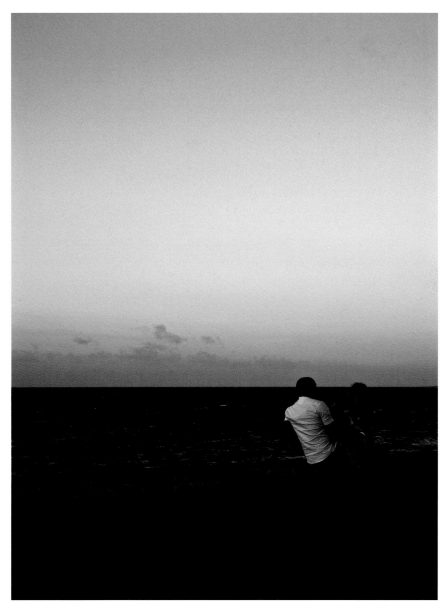

Malecón–a meeting place for many, for two, or all alone with one's art.

Anywhere—under the shade of trees, sitting in these chairs and looking over Havana's Bay and out to sea—one can easily experience the Cuba that so inspired Hemingway. Watching carefully, Hemingway would see how the fishermen in their small boats do what they did every day. Some men would be waist-deep in the bay, immoveable and patient like statues, ready to cast out their nets. Quietly, Hemingway would praise and celebrate these men, as he knew their livelihoods depended on their talents. Most days, Hemingway could feel the warm winds coming in off the sea and he would catch the fresh scent of salt water in the air, and this would quiet him . . . calming him so that his mind was able to explore the possibilities of new story ideas. So much of Havana, and Cuba, centers on the sea, and in this beautiful but merciless sea lies a part of Hemingway's spirit and a vast part of his literary genius.

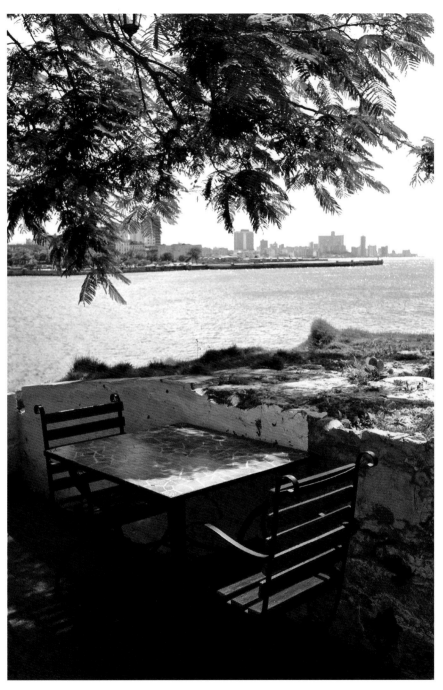

The scene remains beautifully unchanged, despite the passage of time.

Hemingway knew well that life on Havana's Malecón was filled with intrigue and beauty. Cuban bodies, in many geometrical forms, adorn this five-mile-long seawall at all times during the hot days and well into the dark nights. Like Hemingway's love and respect of the sea, they too have their profound relationship with it, and this he witnessed and admired. Certainly, there were always fishermen and countless lovers, yet many others came to the Malecón to speak to the sea . . . talking silently, only lips moving, and asking, with humility and grace, for protection and for good fortune. Having visited the African continent, Hemingway knew that this spiritual connection was part of an African religion, a religion beautifully named *Santería*. He would observe as worshippers would pray to Yemaya–bodies gracefully swaying, their eyes filled with water and light and hope–and place flowers gently onto the sea's surface as a gift and as a symbol of their enduring love and admiration.

Everything is of the sea . . . of Yemaya.

The hurricanes that slam their weight and power onto the island of Cuba, making strong trees bow down nearly to the ground, instill fear and awe in the people. Cubans say that the sea becomes the *Brave Sea*, as nothing can control it and nothing is stronger. They say the sea turns from bright blue to deep black, and this is when they know it will come over the land, flooding their streets and causing power outages and buildings to crumble and chaos and death to prevail. Hurricanes are measured by the height they reach on the Morro Lighthouse, and there are times when the Morro disappears in total blackness. Hemingway wrote strikingly of "the blow" in his novel *Islands in the Stream* and withstood many storms in his personal life, but what he admired most was the aftermath. When the black waters recede and again turn blue, solidarity embraces this island nation and everyone looks like one family, together, caring for those in need and cleaning up after the destruction.

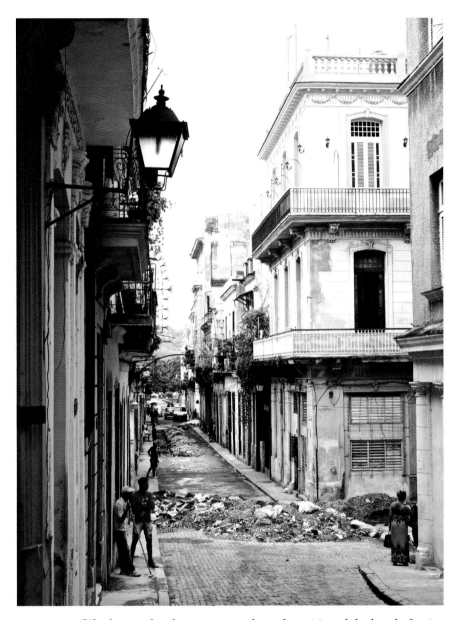

Weathering the elements strengthens the spirit and the bond of unity.

Hemingway knew that, as with writing, there should be nothing easy with fishing: one should have a good catch, but not an easy catch. That first bite, while waiting patiently for something, so patiently that the silence becomes unduly loud, is exhilarating. And at that moment, there is fear–fear that the fish might escape and disappear–like words in the mind. At times, one can even see the fish circle the bait, and it is beautiful to watch how the fish is working. Then the bait is taken completely and the fish knows and thrashes wildly and is now a part of the line . . . part of the story. And this is triumphant. And then you wonder what the fish will look like in your boat. But you must not hurry–you must be patient and wait and play and fight, keeping the fish in the water until it is ready. Once in the boat, the greatness of the fish is realized. And this, like a good day's writing, is what is regarded as a "good catch."

The seemingly simple is indeed complex and always worth the effort.

There is a lovely photograph taken of Hemingway that, perhaps more than others, captures him with concentrated purpose and great joy. The image shows an older Hemingway, bare-chested and pants rolled high, with a cap and spectacles on, helping haul a fisherman's net onto shore–his daily catch and meager reliance. Hemingway felt far more comfortable, and received added delight, when helping people do what they were born to do. Rather than subject himself to the monotony of the rich and the famous–those who had it all and could only look back with self-glorification–he sought the common man who continued to represent and to mirror the struggles of daily living with but few belongings and longings. Hemingway himself was a simple man, a man who cast a wide net for those whose work would always guide humble lives and command gallant actions.

A still-life image of the humility and dignity of the common man.

The sea carries a message from all those fishermen who knew and loved the man they fondly called Ernesto. Those fishermen, many long dead now, are not talking men—especially on land—only speaking when they must. What they say through the sea is that Hemingway knew how to communicate with them . . . he spoke their language—not always their words, but their *language*, simply and frankly and with integrity, and followed, always, by action. They would take drink together and they would pass time together in pursuit of the fish. They are humble, and Ernest was humble. As one Cuban fisherman once remarked, "He never placed us to the side. And he listened to our histories, our stories, and shared all he had, always. Even if it were one fish, he would not wait to have ten to share the one." For these men, the sea has been their whole life, and they knew that Hemingway's life, too, was the blue sea and the fish that lived in it.

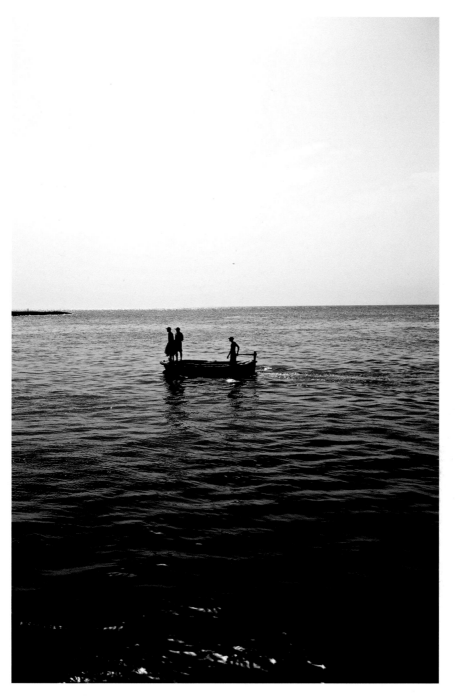

The language of fishermen needs no words.

The breeze coming off the sea in the early evening, just as the sun begins its colorful decent, is gentle and soft along the Malecón and even up high on hill-tops. Cubans believe there must be vitamins layered in the breeze because a body feels calmly refreshed and renewed, and ready to participate in what the night brings. Hemingway's farm sat high on a hill and received this tender breeze, which moved him toward lovely evening meals with Mary, always lit by candle-light, as was her preference. Together, they would take long and winding walks along the pathways of the farm, simply walking without need for voices. Nature, when noticed, provides remarkable transitional elements. Along the water's edge that surrounds this city, Havana's Balcony, the breeze is but one such notable element that, when experienced presently, fits beautifully into the repertoire of what drew Hemingway to live for so long and so well in Cuba.

Everyone is touched by the lovely breeze near the Malecón.

The whispered truth about Hemingway and fishing is that those Cuban fishermen who knew him well respected his talent but respected even more, and admired deeply, his prose. Hemingway loved to fish, he loved Cojimar, and he loved Cuba, but he was not as skilled with a fishing pole as he was with a pencil. It was known throughout that their Ernesto had boundless enthusiasm for the sea and for fishing and for the fish, but that his best skill, and his utmost passion, was for writing. These fishermen knew well about the many great challenges that the sea presented and, although they were not writers, they instinctually knew about the many challenges of writing. They knew that even when Hemingway was out on the sea physically, there was always a part of him, mentally and spiritually, that was still struggling within the pages of a story. And this reality, this truism, represents yet another dimension of what drew these artists-of-the-sea to respect, confide in, and befriend Ernest Hemingway.

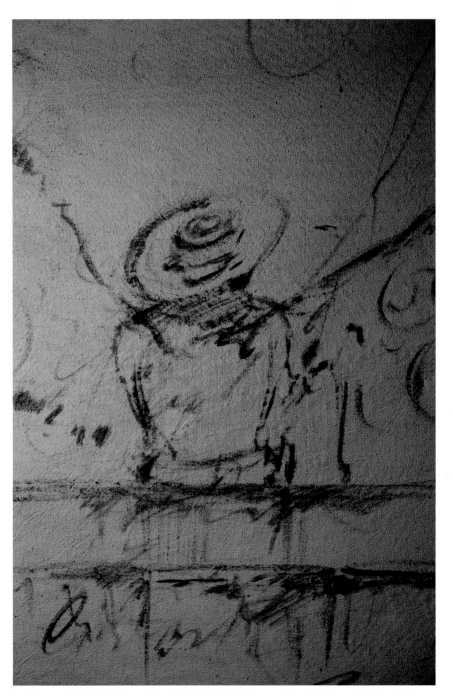

A sketch of the fisherman, contemplating the sea, like Hemingway himself.

El *béisbol* is the sport of passion in Cuba, and this shows beautifully in Hemingway's Cuban novella, *The Old Man and the Sea.* In fact, Santiago's monologues on baseball help paint this story in Cuban colors. Baby boys already have a glove and ball and bat in their rooms, waiting for them to crawl, then walk, to the field. Whether they are on a field or on a street, practicing is a way of life. When Santiago reflects on baseball, one must connect the sport to life and, specifically, to life as a fisherman. Baseball requires discipline and patience and to be in the right place at the right time in order to catch the ball; this is also true of fishing. One must keep one's poise in baseball and also on the sea, and one must be physically and mentally prepared for anything to come one's way. Hemingway knew that baseball and fishing demanded focus, and that both involved one's soul. This adds yet another dimension to Hemingway's novella and to his old man, Santiago.

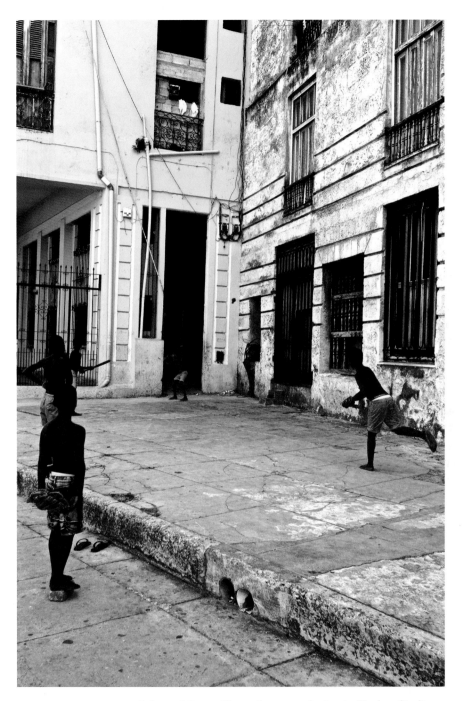

Ask, and they will say they are playing in Yankee Stadium.

To be a Cuban fisherman is to have a love of solitude. These men are quiet and humble, and a significant part of who they are suffers when on land. A fisherman is alone on the sea but lonely on land, and to be balanced on land is far more difficult than it is on the sea— because the sea moves and is alive. The fishermen that Hemingway trusted and befriended were quietly perseverant, often speaking to the sea far more than to one another . . . and hardly at all to those who could never hope to understand. Being alone for these men of the sea, even when others were present, was normal and was respected by those who loved them, but it held great risk. Unlike most foreigners, Hemingway was both accepted and respected by these tested and sincere men for the simple reason that they saw in him their own heart, their own hands, their own eyes, and their own sense of solitude.

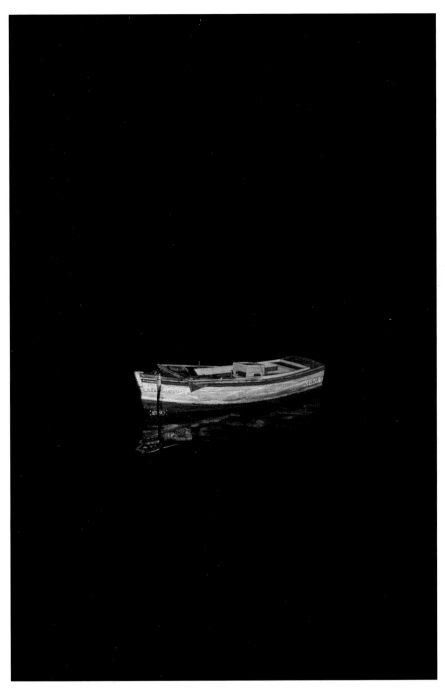

Writing, at its best, is a solitary life.

The many white islands–like a pearl necklace–surround the Cuban mainland. They entranced Hemingway and called his name. Cubans say that these islands offer a rest to one's mind, and that they are a place to heal. On the main island, for work, Hemingway had his bedroom, standing in the early mornings on his lucky kudu skin while pressing the keys of his Royal typewriter; for pleasure, Hemingway had the grounds of his home, his Finca, and the local children that would come there to play baseball on his field; for entertainment, Hemingway had bars like the Floridita, where he would drink and regale Hollywood friends; and for true seclusion, and to ruminate and refresh his spirit, Hemingway had these small and lovely and enchanting islands. Hemingway's world presented constant personal and professional challenges, and it was here, surrounded in the lightest of blue and where the deep seafloor seemed within an arm's reach, where he could reflect on all he had done and all he would still do.

A place where the mind, body, and spirit may connect.

There are no public personas on the open sea. Those fishermen who knew Papa well understood that he was reserved and that he valued his private identity over his public personality. Those men were insistent on that fact, and said that "When others write of Ernest Hemingway, they add more to the story than what is there. They embellish, and this is not what he liked and this is not what we liked." There are stories and photographs showing Hemingway in a drunken and careless light–a puppet put on display and mocked. Hemingway would rage against these depictions, and it seemed as though his comrades, the fishermen, knew more about his true character than even he knew. The sea is an equalizer, perhaps the greatest socialist experiment one may experience. And those men, who lived *por el mar, y para el mar*, knew certain truths about the personality and about the behavior of Ernest Hemingway–truths that some critics and scholars can never hope to know.

Hemingway was absorbed in the blue sea.

Santiago, Hemingway's code hero in *The Old Man and the Sea*, is held in the highest esteem in Cuba, as he embodies the essence of honesty, effort, and equality. Hemingway admired the labor of the common man, especially that of the fisherman, and created Santiago in the likeness of, and with the virtues of, those fishermen he knew from Cojimar. Santiago's actions, both on land and on sea, are measured and contemplative; his mind is disciplined and yet free; and when around another, he is compassionate and happy and giving. In the end, Cubans celebrate Santiago's decision to go farther out into the sea than anyone, and they respect the brotherhood he shares with the great marlin on his line, and they cry for the devastation wrought by the sharks that quickly spoil his great fish. All is renewed and awakened in Santiago, and those Cubans that know his truth see the old man as the perfect and beautiful example of how to live a life.

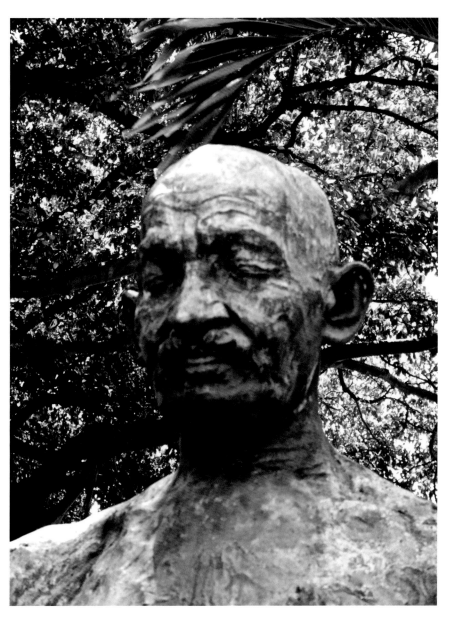

Apostol de la paz, no de la violencia.

There are fishing tournaments that take place all around the globe, but perhaps none is better known and its prize more coveted than the annual Hemingway International Billfishing Tournament, held at the handsome Marina Hemingway. The most serious of all fishing devotees enter hoping to claim the prized trophy, one fashioned in Hemingway's likeness. Hemingway and his *Pilar*, under the guidance of his trusted captain, Gregorio Fuentes, won three times in the 1950s, and President Fidel Castro took first place in 1960, shaking Hemingway's hand in victory as can be seen in a famous *Life* magazine photograph. Today, in this tournament, it is always catch-and-release. One wins the fight, but releases the fish back to the sea. This gesture is a triumph, a measure of being an aficionado, and is an exhilarating and soulful part of the process. Winning, most medalists have said, requires luck and knowledge–no one knows for sure which comes first–but it is passion that drives all those involved in this Hemingwayesque day.

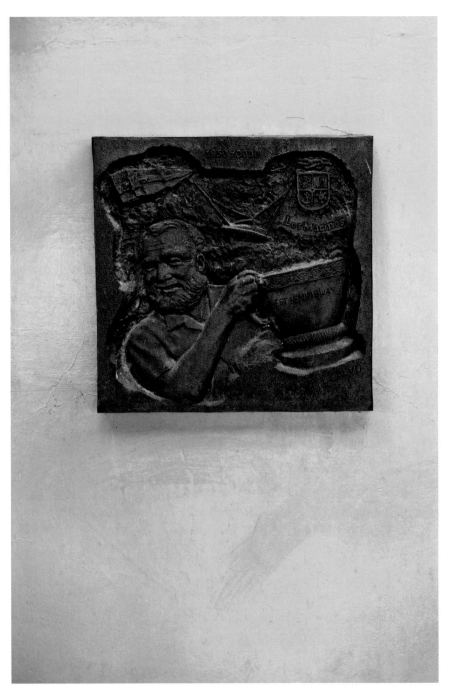

A plaque of the most respected big-fishing tournament in the world.

A close and dear friend of Hemingway's, Mario—now profoundly weathered and aged—is one of the many fine and true fishermen of the village of Cojimar. Mario first noticed Hemingway because of his height. Looking into Mario's deep blue eyes, Hemingway asked for help in cleaning his day's catch, then humbly offered a tip and a cold drink. The two would, for years, pass time together out on the sea and in along the small crescent shoreline of Cojimar. Hemingway would listen to Mario speak about his life and how, at seven years old, he felt a passion to fish—a passion stronger than the necessity for money or even for dinner. He told Hemingway that the sea was his church—a place for the poor and the simple to touch the hand of God, and he said that the happiness and fulfillment of being out to sea far outweighed the dangers it could present. He believed that being on shore, surrounded by land, was more severe than facing the roughest of seas, and that it was where he felt most lonely.

The sea can break the hearts of all who live for her.

Every Cuban fisherman speaks highly of the blue marlin, and every sport fisherman longs to hear each man's experiences. Along the docks of the Marina Hemingway in Santa Fe, one can listen to such stories, and while these Cubans speak, one can almost watch the great fish surface from their colorful eyes and almost see Hemingway listening intensely. On a clear afternoon, a Cuban fisherman quietly and confidently spoke: "I love to see the marlin flying out of the water. Yes . . . everyone has a different feeling when watching the marlin going after the bait. There is much concentration. The fighting chair and the wheel must be perfectly in sync . . . the fisherman and captain must be as one. The blue marlin always moves differently . . . some go deep, some on top, shallow, and others fly. This is why drag is so important, so as not to break the line. For twenty minutes, sometimes forty, there is an emotional connection to the fish and, of course, among the crew." Then he paused and said, "In the end, even by winning the fight, you lose something."

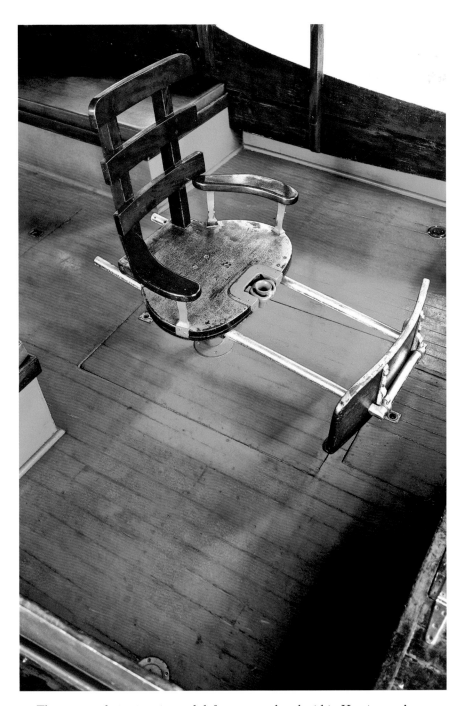

The stories—their victories and defeats—are echoed within Hemingway's pages.

There is one restaurant called Santy that, had its doors been open in Hemingway's day, would have undoubtedly been his prized retreat and drinkery. The restaurant is built like the home of a true and humble fisherman. There is nothing formal, no fancy style—just working fishing poles hung from old wooden beams, a weathered planked floor built out over the water, lamps made from buoys, and three boats tied right up close to table-tops. One can almost hear the voice of Santiago himself welcoming guests: *Ésta es mi casa . . . you come, you eat, you speak, you drink, and then you leave . . . it is like this here*. Nowhere else can one come as close to eating in a seaman's house where the fish was caught hours, if not moments, prior to serving. Santy's owner humbly says to his guests, "We have three boats . . . one is always fishing, working for the restaurant. We are simple. We catch and we prepare." Hemingway enjoyed time spent in restaurants, and this is one where his time would have perfectly matched the passion he had for the sea and for fishing.

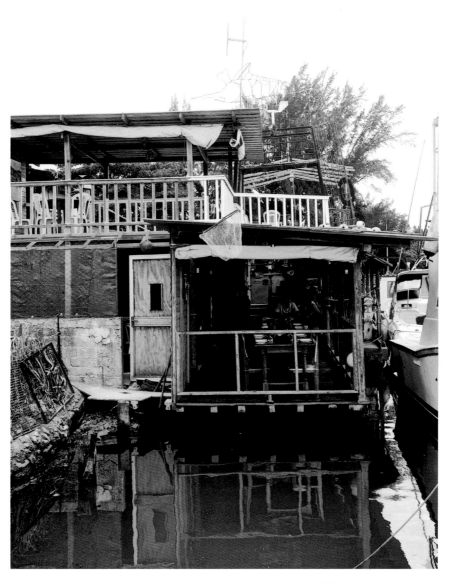

Santy–the setting where all fishermen wish to be.

The sea surrounds Cuba for nearly four thousand miles and runs up against both harsh rocky shorelines and pristine white beaches. No doubt, the allure for Hemingway was the sea and the Cuban people, especially the fishermen of Cojimar who inspired and moored him. More than four thousand islands and cays dot the sea surrounding Cuba, more than Hemingway could ever hope to discover. The Atlantic Ocean and the Caribbean Sea, along with the Straits of Florida, the Old Bahama Channel, the Windward Passage, and the Gulf of Mexico provided Hemingway with intrigue and beauty in all directions. He was fascinated and mesmerized. Certainly the land was there as inspiration, but, for Hemingway, the sea offered the greatest pleasure and provided a place where he was able to breathe freely, far away from the constraints of fame. Hemingway often said that his time on the sea, on his boat, *Pilar*, was his happiest, and that the sea renewed him, both as a man and as a writer.

The view from all directions—for contemplation, dreams, creation, and peace.

It seems as though Picasso had painted these stairs . . .

. . . or Gauguin, with his bold colors.

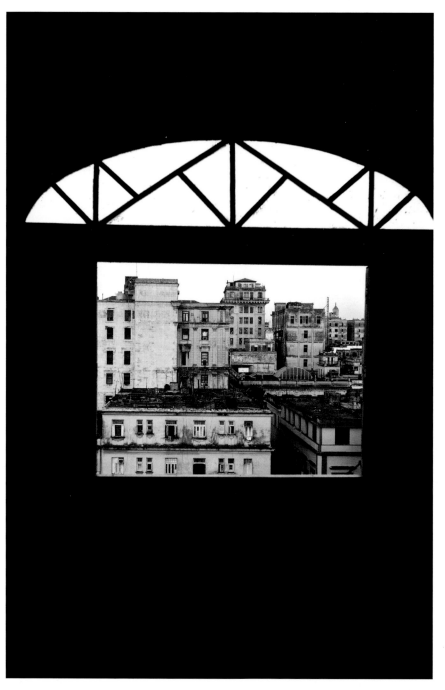

Despite years of erosion, natural frames show that
Cuba's architectural beauty still lives.

The Land

On shore and in Havana, Hemingway was absorbed in a more cooperative and less private life than what he found on the sea . . . a life that, because of the Cuban people, their alluring culture, their profound history, and their exciting traditions, provided great joy, intrigue, and purpose for him. The Cuban landscape, socially and politically far away from his birth home in Oak Park, Illinois, was the perfect setting for Hemingway to be his true self. He admired the warm and simple Spanish architecture. He could feel the sway of the Cuban music as it drifted through the streets and into the souls of the people. He coveted his walks throughout the city, in shorts and loafers, sometimes with drink in hand, after having had good luck working. He enjoyed entertaining–movie stars, servicemen, and American and European friends–at his home, the Finca Vigía. And he was at peace when spending time and often helping to support the local people of his town in San Francisco de Paula. One must always remember that Cuba was Hemingway's most permanent and treasured home.

Although now a popular museum welcoming visitors from around the world, Hemingway's home, the Finca Vigía, feels like it is waiting for its owner to return and resume his activities. The Finca is now a collection of the books he owned, the clothes and shoes he wore, the Glenn Miller records he played, the gin he drank, the photographs and paintings he collected, and the various items gathered throughout years of travel. All of these belongings remain exactly as Hemingway left them. It is almost as though there were an ancient belief stirring among those overseeing the Finca that if the possessions of the departed were left exactly the way they were, the spirit was then encouraged and invited to return. Many who tend to the home, keeping it clean and white and welcoming, claim to have felt Hemingway's presence throughout the grounds, near the pool, or standing while writing over his typewriter. Hemingway's Finca Vigía has a sense of suspension surrounding it, and his spirit is deeply longed for.

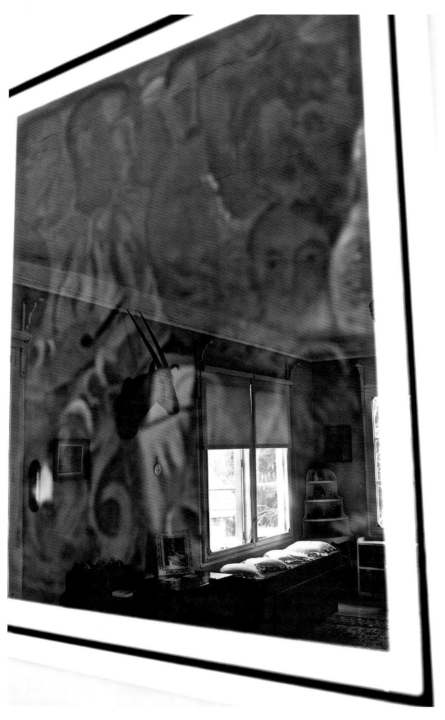

The sun, the people, and the home are as one.

For Hemingway, walking the sidewalks and pathways of San Francisco de Paula and of Havana was an integral part of his writing process. Like those Cubans who walk, seemingly endlessly, throughout the city and towns, he did so more as a way of bringing himself closer to his next day's work. Walking in Cuba is not simply a measure of reaching a physical destination, but is often a way of strengthening relationships and moving them forward. A person, or a couple, might begin to walk in anguish or confusion, or even sadness, and by the end of that walk find peace, clarity, or happiness. Hemingway's deepest relationship was with his prose, and at times the right words eluded him, requiring distance and patience. It was under the heat of the Cuban sun that, while walking, Hemingway worked through the problems that besieged those attempting to find harmony with someone or something they love.

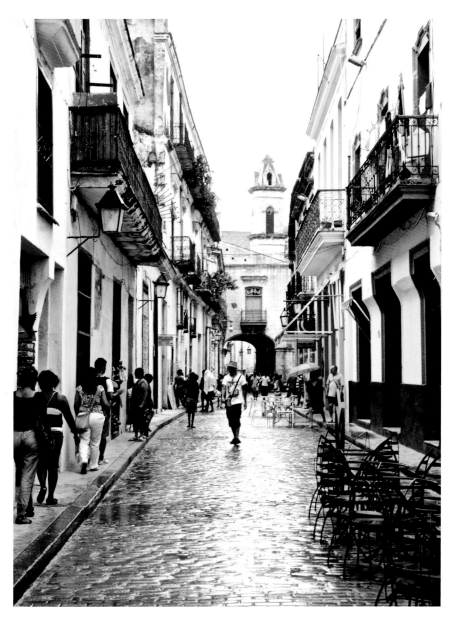

El vagabundo—walks city streets in search of fulfillment.

The first time A. E. Hotchner, a future confidant and biographer, saw Hemingway was in the bar Floridita. Hotch, as he would come to be affectionately known, sat surrounded by people eating, drinking, and dancing. He watched as Hemingway spoke in fluent Spanish, flashing a dazzling smile, and was mesmerized by the pure elation that exuded from him. This unclichéd image–far removed from boxing, hunting, or fishing–showed Hemingway in love with life while surrounded by people dancing. Dance was, as Hemingway knew well, part of the body and the spirit of the Cuban people, and he embraced the joy that could fill a room. Cubans believe that when one dances, especially in their later years, age can be met with happiness, grace, and approval. All this, Hotch noted within the first few minutes of meeting the American, the Cuban, Ernest Hemingway . . . and this glimpse of Hemingway surrounded by dancers in his favorite bar stands, emotionally and beautifully, in strong opposition to the image of a suicidal writer.

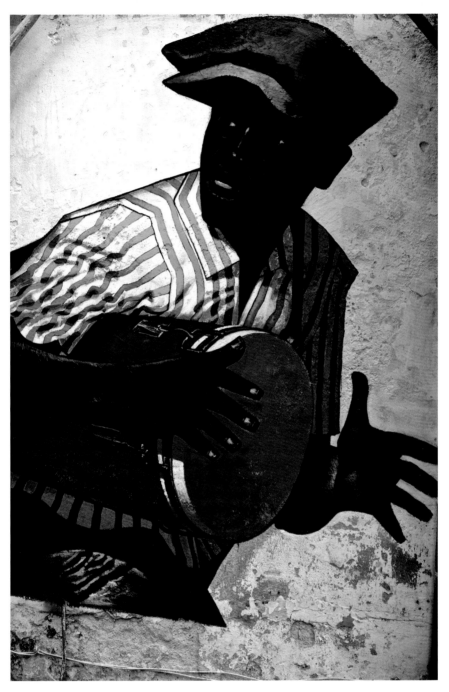

Perhaps there is no better way to describe Havana's nightlife than in
T. S. Eliot's line, "Darkness shall be the light, and stillness the dancing."

So much depth and richness and honesty can be discovered behind the seemingly simple, the unadorned, and this lovely and significant understanding served Hemingway's life and prose well. In Cuba, one strong and lasting image of this reality can be seen in their national flower, the *mariposa*. This delicate white flower named for the butterfly is shaped and moves in the breeze effortlessly. Being as white as a fresh page, revolutionaries would, since Cuba's Ten Years' War in 1868 with Spain through Castro's triumphant revolution in 1959, roll small white papers with secret and vital messages in support of the fighters and place them within the flower to resemble any one of the gentle petals. Women would then wear the flowers in their hair, seemingly as only decoration. Just as the butterfly symbolizes the joy and delicacy of freedom, the small and beautiful *mariposa* is an important and powerful reminder to Cubans and deeply symbolizes their continued spirit of independence.

Brilliant is the Cuban sun, freedom, and a little flower.

It rains often within the pages of a Hemingway novel or short story, setting a quiet and contemplative tone and often an emotional condition of loss and longing. The rains in Havana are no different, as the sound, the look, and the feel of being forgotten and yearning to be found add something uniquely pensive yet beautiful to the city and to its people. The rain is soft music to most Cubans, and it looks like the ocean is coming down from the sky; often, it is not clear where the ocean ends and the sky begins when it rains. When it rains in Havana, children dance on wet cobblestones. Others walk along puddled streets and slick and broken sidewalks. Most, though, huddle close together under concrete shelter. They patiently stare into the rain and contemplate their place in the world. When in Havana, and in the rain, one understands more completely a Hemingway story set in the rain, immersed in loss and longing.

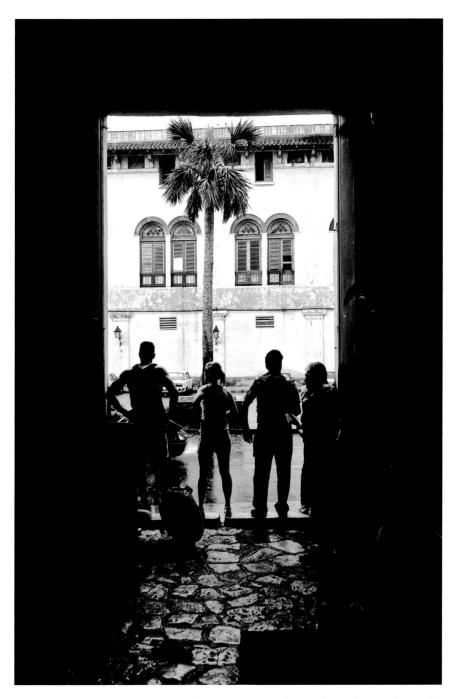

They patiently stare into the rain, contemplating their place in the world.

Cuban women, Hemingway believed, possessed great beauty and endless inspiration within the darkness of their eyes, and they helped inspire alluring and unforgettable female characters in his stories. It is believed that Cuban women have the *fórmula perfecta* regarding how to live a life and how to delight in and care for a man. Being pretty, by always allowing their natural beauty to emerge and by living an endless dream of romance, is fundamental to this formula. There is romance to be found in the most common of activities and the most ordinary of moments. When working outside the home or when taking care of the children or when collecting groceries for dinner, around every corner is the possibility . . . the possibility that their lover might appear. Cuban women do not have much, little money and threadbare clothes, but what they do have is a lovely way of placing romance at the center of their existence, and this powerful and alluring impression is what Hemingway observed and appreciated.

There is strength in delicate acts along the streets of Havana.

Good drink and conversation define much of who Hemingway was when not writing. And, without doubt, the drink to define all of Cuba—in its rich tradition and resilient culture—is Havana Club Rum. Rum is Cuba, and this brief and simple fact is one Hemingway knew well and respected immensely. Within his stories, Hemingway always included weather, and one can argue that in any Hemingway story, the earth is the only lasting hero. The same is true of Havana Club. The climate and the earth give rise to the sugarcane, and this natural cane is the foundation of Havana Club—making the earth and the weather, once again, the hero. Like Hemingway's prose, Havana Club is not simply made for sale, but is made from the heart. Man tends to think so highly of himself, but in the pages of a Hemingway novel—and in Cuba's special rum—man will understand his place.

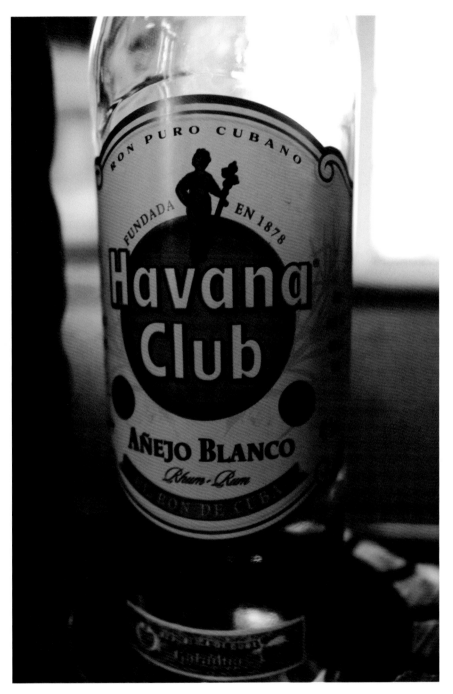

A spirit in which the simple hearts delight can be found in rum.

The life that spills down from balconies and onto Calle Obispo, a long and narrow street in which Hemingway could easily be found walking, is filled with movement and intrigue. Some Cubans can be seen cleaning what little they have, some conducting business transactions, some fixing what is broken . . . all while children are playing with makeshift toys and others are simply sitting and looking at it all, seemingly expressionless. All of this activity is set against the loud noises of a bustling, yet crumbling, city. Being a wanderer and having a keen sense of observation, Hemingway would enter scenes such as this into his mind for later use in his writing. There are those paragraphs in Hemingway's work that make the reader stop and feel and hear and see all that is happening along a street. Hemingway had the precision and the talent to place the right details perfectly so that those same rich and intriguing scenes of daily life he witnessed could be experienced by all.

She is old, caught in the silence of a bustling street.

A letter from Charles Scribner, sent to the Finca Vigía in June 1947, is how Ernest first heard the sad news that his dear friend and trusted editor, Max Perkins, had died. The relationship they shared beginning in Paris in 1924 was long and loyal and caring and close. Hemingway believed Perkins to be his best and most dependable friend, and the finest advocate for whom a writer could hope. Often, in the Cuban culture, when death comes to a close friend, those remembering will say, *Te acompaño en tus sentimientos.* The best English translation is that *I remain, but my feelings are with you.* Throughout the rest of his life, Hemingway would write as if his friend sat upon his shoulders. Perhaps, even–given the importance and grace and wisdom Hemingway places in his descriptions and within the dialogue of Santiago, his protagonist in *The Old Man and the Sea*–there is a small piece of Max Perkins to be found.

There are many good fishermen, but only one you.

Strong and inspiring female characters permeate the work of Ernest Hemingway, and also appear brilliantly throughout Cuba's proud history of independence. Without doubt, the strongest of females in Cuba's history is the mother of Antonio Maceo, Mariana Grajales. Maceo, more than anyone of his time, put fear into the hearts of the Spanish colonizers in the late 1800s, and his courage and determination was driven into his heart by Mariana. A woman never to hold her tongue, and a woman of direct and decisive action, Mariana passionately encouraged all of her sons to go and fight to protect the country she so loved: *When your brothers are covered in blood, you, too, join the fight . . . independence needs you!* Hemingway certainly knew of Mariana, and her likeness can be found within the powerful and outspoken character of Pilar in his novel about revolution, *For Whom the Bell Tolls.* And the new post-revolutionary women of Cuba–those working in medicine, engineering, athletics, politics, and the military–follow the example of Mariana.

She fights and is ennobled by her scars.

The writings of José Martí were visionary, and have withstood the years by remaining in the minds and in the actions of the Cuban people. Martí was a writer who inspired independence and instilled pride, and his words filled the imaginations of the Cuban people, encouraging them to rise against Spanish colonialism in the late 1800s. His words continued to echo strongly into the 1956 revolution as Castro and his band of guerrillas took to the Sierra Maestra mountain range. When, as a young man in 1953, Castro was arrested by the dictator, Batista, he was questioned and was asked to reveal the leader and the instigator of his anti-establishment actions. Castro said simply, José Martí. He said that Martí's words, and their sentiment of solidarity and justice for all, were solely responsible. Eventually, after the success of the revolution, Castro would also credit Hemingway for teaching him the ways of guerrilla warfare though Hemingway's novel, *For Whom the Bell Tolls*. Both José Martí and Ernest Hemingway moved armies with their words.

A fierce fight takes place daily to respect the principles of human rights.

Given his history of supporting the working class, especially as seen during the Spanish Civil War years, it is reasonable to presume that Hemingway did not respect the Batista regime–one that strangled the livelihoods and the rights of most Cubans prior to Castro's revolution. This is well known and well documented but not mentioned nearly enough. Life was bad for the poor and most of Cuba was poor. But for the rich–those who owned and controlled the land and its people, and who did not choose to see the poor–Havana was a playground, where anything was possible. There was no healthcare for the poor, no electricity, infant mortality was high, and, perhaps most important for Batista to maintain power, there was no education for the vast majority and illiteracy was rampant. Most Cubans living outside of Havana were unable to write their names, using an *X* instead. Hotels, restaurants, and casinos flourished, while people suffered. And any talk of revolution was met with torture and killing. Cuba was ripe for change, and Cuban residents like Ernest Hemingway supported *la Revolución.*

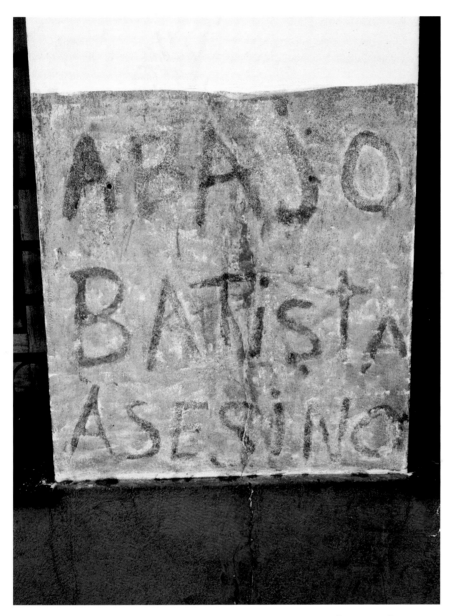

Murals remain: *Down with Batista, the assassin.*

Fidel Castro wanted everyone in his country to be rich . . . rich in identity and rich in dignity. No matter one's political or social position or philosophy, most can agree that when politics serve the few—leaving the masses to suffer—change is necessary and revolution is inevitable. It is hard to believe that a young man who studied law at a university would organize and lead to victory the most studied and controversial and lasting revolution in modern history. Everything Castro promised to the masses—as he fought his way through the Sierra Maestra mountain range—he delivered, and he did so without outside support. Castro was not rich, and he was not a soldier. But in 1956, as a political exile in Mexico, he decided to place his love of the Cuban people, and their well-being, before his own life by returning to Cuba to put an end to the massive inequality. It is this simple and honest and selfless and brave act that earned the respect of the island's most famous resident, American author Ernest Hemingway.

This is what Fidel Castro said: *I am not a communist,*
neither is the revolutionary movement.

A toast that is said among Cubans and sounds like it came from the pencil of Hemingway himself is this: *To Che Guevara . . .We shall toast to this man in belief that we fight and work for all of humanity . . . Seremos como él . . . We will be like he.* For the Cuban people, Che is the example of a life to live. He was a simple man and a knowledgeable man, and brave and passionate, and he worked hard and believed that the world could be better. In the mountains while fighting alongside Castro, Che would, as each small village was liberated, establish a medical clinic to administer the best care he was able to provide. His knowledge as a doctor was generously given to people who were medically neglected and knew nothing of free healthcare. Girls and boys in Cuba continue to raise their right hand out and up and in front of their heads, fingers extended, like a knife's edge, in support of this national hero and in admiration for all he gave to the well-being of their country.

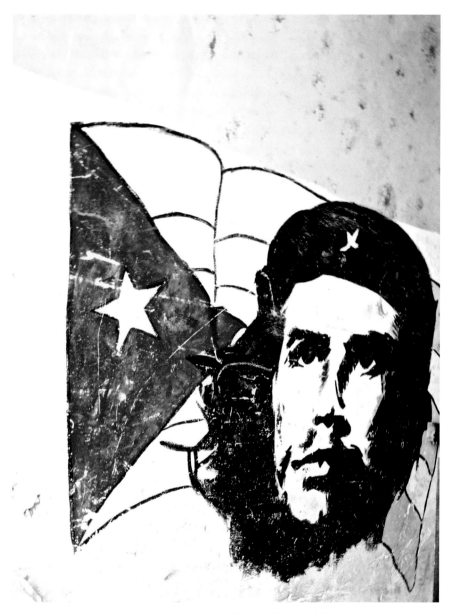

I will be on the side of the common people. –Che

Fighting alongside Fidel Castro and Che Guevara high in the mountains was another man named Camilo Cinfuegos, a revolutionary with the characteristics necessary to make a believer out of Hemingway. Camilo, Che's closest comrade, was a man for the people and was, arguably, the more friendly and the most popular among *la gente Cubana*. He was a humble man, always smiling, and was forever ready to give a minute even to the most impoverished of *campesinos*. Because of his courage and his belief in true independence for the people of Cuba, and to honor his legacy, each twenty-eighth of October, all Cubans–led by the children in the morning–bring flowers to the sea in remembrance and in promise that his image never be forgotten and that it is seared into their minds and into their hearts. Camilo's reflection can be seen, beautifully and undoubtedly, in the actions and deeds of Hemingway much before Castro's Revolution.

Few men have succeeded in leaving a personal mark, like Camilo.

When Hemingway did reveal his political view through the hearts of his characters, common good and true socialism emerged and prevailed. Hemingway's writing has within it the message of equal justice and fraternity for all. Everybody fights for something, and Hemingway was no stranger to that fight. Cubans, too, have at the center of their hearts the essence of solidarity and the spirit to contribute to other countries in times of need. Cuban doctors, teachers, and engineers are shared with the world and have always given time, energy, and expertise for the greater good of humanity. Their mantra, one mirroring Hemingway's philosophy, is simply to help countries with what they have–not with what they have the most of, but with what they have. This selfless and lovely spirit also includes taking care of those who come to visit or to live in Cuba, and this is what Hemingway experienced when he arrived in the city of Havana and settled within the pleasing town of San Francisco de Paula.

Cuba, a leading country on the United Nations Human Rights Council,
has championed oppressed people around the world.

Had Hemingway seen, from his Finca or from one of his favorite cafés in Havana, the raising of the Cuban flag in Washington, DC, on July 20, 2015, he would have surely danced the night into day. He would know that after fifty-five years of political unrest and suppression, Cubans now have a small place they can call their own in the capital of the United States of America. He would know that the Cuban culture and their traditions were now represented freely within the greatest country in the world. And he would feel that the people he loved most would now find it easier to dream and to see that something better for their lives was on the horizon. Being wise, however, Hemingway would be cautious, simply because governments are complex and fickle. The past, he would warn, must not be forgotten but must never spoil the present nor destroy the future. Trust–Hemingway would caution–between the United States and Cuba should not sleep with one eye open.

"We are determined to live as good neighbors." John Kerry, 2015

Many who knew him would say that in Cuba, in Havana, and specifically at the Finca, Hemingway found peace. For nearly thirty years, Hemingway's home was where he felt most free and most serene. He loved the lush and colorful grounds of his home where he would take walks alone or with his wife, Mary, and he enjoyed sharing all he had, including his time, with the local people of his town. As scholars write the many scientific reasons explaining Hemingway's death, one simple word escapes them: *peace.* This sentiment is echoed, through generations, by the voices of those who were close to Hemingway. They simply believe that their friend ultimately committed suicide because he missed, wholly, the peace of his Finca. Certainly, there is no dismissing Hemingway's physical and mental challenges and conditions when considering his death. But there are Cubans who genuinely believe that had Hemingway not been forced to leave his adopted homeland, or had he been allowed to return, he would not have chosen to end his life nearly a year to the day of leaving behind his beloved and peaceful residence.

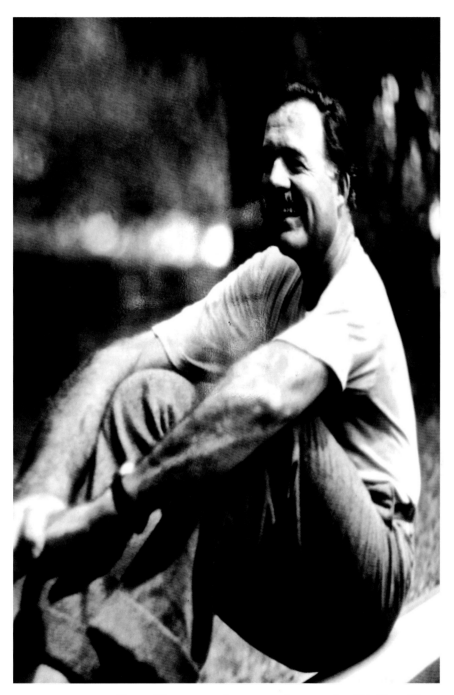

Ernest Hemingway, happy, on the grounds of his Finca Vigía.

The wind chases the great clouds over all of Cuba—over flat and rolling plains and over the grandness of the Sierra Maestra mountaintops. What Hemingway loved most was feeling the wind that came in off the sea, passing over Havana, and gently touching the hilltop where his home stood. Cuba's geography enchanted Hemingway; he appreciated all that grew from the land—the tobacco, the coffee, the sugarcane, the mangos—and he celebrated the people who worked the land to provide for their families and for their countrymen. Cuba's grand landscape makes it the seventeenth largest island in the world, and the Cuban people might, arguably, be the most courageous and tenacious in all the world. Generations and political ideologies, Hemingway knew well, would not last . . . but the Cuban earth would go on forever to tell its story and to inspire all those who came to her with a humble heart, an artistic eye, a keen mind, and an open hand.

What is needed is to touch Cuba with a warm and tender hand.

The flower outside laughs.

While in the vase, it smiles.

All his life, he looked at words as if seeing them for the first time.

The Work

In Hemingway's work, every detail of his writing process mattered greatly. There is nothing–no word, no punctuation mark, no edit, no space–that does not belong. Composition, and the work and focus and care required to compose clear, meaningful, and alluring prose, consumed Hemingway's every thought and action. All the places and all the people and all the experiences and conversations encountered during a lifetime were there at his fingertips each morning while he wrote. In Cuba, more than any other place, Hemingway would work well and without interruption. He was enveloped within a lovely and peaceful home, and those Cubans who worked at the Finca respected the time and space he needed in order to create sound and lasting writing. While in Cuba, Hemingway completed major novels such as *For Whom the Bell Tolls* and *The Old Man and the Sea*, and he began other great novels, published posthumously, such as *The Garden of Eden* and *Islands in the Stream*. Toward the end, he also worked on his remarkable memoir, *A Moveable Feast*. Despite his storied triumphs at sea and on land, Hemingway was a writer, first and last, and his work will always be his true legacy.

The prose Hemingway wrote–his con-
cise and clean and simple construc-
tions–reflected beautifully the essence of
the relationship he shared with Cuba's
people and its landscape. Cubans in his
neighborhood of San Francisco de Paula
might have believed they were not good
enough for a man of Hemingway's stat-
ure and class; after all, they were poor,
making do with little, and he seemed to
have it all. But what drew them to one
another was the similar way in which they
thought about life and about serving peo-
ple, and about being inviting and honest
and hardworking. Both Hemingway and
the Cuban people were simple in actions
and in work and in expression, yet not
simplistic. They knew about the true
depth that accompanies all things simple
and honest, and it was within this depth
that they understood and appreciated
one another. These same basic principles
remain the cornerstone of Hemingway's
prose, and the foundation of the Cuban
people.

Hemingway believed that good living is true living.

It was Martha Gellhorn—journalist, war correspondent, and novelist, and Hemingway's third wife—who discovered Hemingway's Cuban home, the Finca Vigía, and encouraged its purchase. Ernest was satisfied with staying in the Hotel Ambos Mundos in Old Havana with his typewriter and fishing gear, but Martha wanted him to have a more suitable home; she knew Hemingway needed a peaceful and inspiring residence in which to write and to pursue his interests. Having looked at many properties, Martha eventually rented La Finca Vigía, falling for its expansive yet run-down one-story Spanish structure and its fifteen acres of overrun farmland. At first sight, Hemingway believed the place hopeless, but Martha, using her own funds, had the walls whitewashed, added simple furnishings, and hired gardeners to tend to the land. She instinctively knew that was the place for two people to write in the cool mornings and enjoy drinks while sitting under the mimosa trees. Upon seeing her efforts and knowing this was the best place for him to write and live, Hemingway embraced what she had created and purchased the home in 1940.

The inspiration of a particular place is both visual and emotional.

There was a young man named René who was silently and lovingly recognized as Hemingway's Cuban son. A local boy from San Francisco de Paula, René was immediately embraced by Hemingway and eventually became the overseer of the Finca and all day-to-day activities and responsibilities. For fifteen years, René dutifully provided Hemingway with a lovely sense of belonging and with a peaceful home conducive for good writing. The Finca required constant upkeep, and René was responsible for a permanent staff of loyal gardeners, carpenters, and maids. Everyone who worked for Hemingway knew the value he placed on his privacy when writing, and it was René who ensured that no one disturbed his routine. When asked if René had a favorite book of Hemingway's, he would say *The Old Man and the Sea*, as the writing was clean and sharp and the characters were honest and hardworking, and there was affection throughout the entire story. Hemingway was indeed a great writer, but he was also a father figure to a local Cuban boy named René.

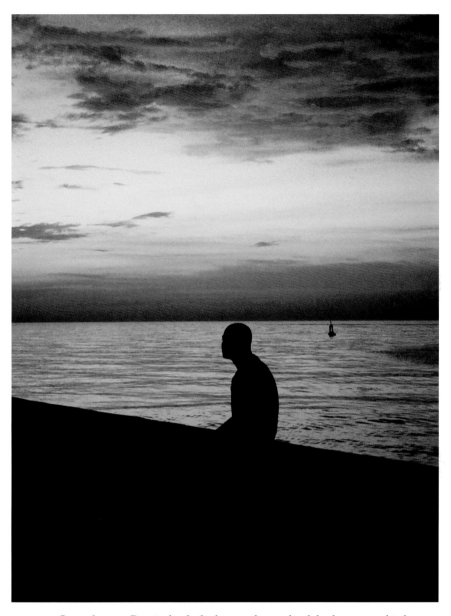

One of many Renés, he feels the gentle touch of the breeze and is happy.

Hemingway listened how children told the stories of their day, sharing their simple discoveries, joys, and concerns while navigating in a difficult and challenging world. Children have a way of bringing life to simple endeavors, making ordinary experiences fresh and forever meaningful. The children Hemingway came to know that lived near his home in San Francisco de Paula represented the ideal of honesty, innocence, and purity; they were uncorrupted and did not have their beliefs stolen by envy, cruelty, hate, or war. This was a relief for Hemingway, and kept his mind full with wonder and discovery. Being around the children in his neighborhood not only served them well, but they seemed to symbolize and inspire the simple and honest and pure sentence structures Hemingway sought in his prose. Certainly Hemingway's ideals and philosophies on politics, war, religion, economics, love, and the hardships of life were complex. The children, however, and the lens through which they viewed life, helped ease Hemingway's mind, allowing him to create clean and clear and significant writing—writing that illuminated meaning and provided the purest of emotion.

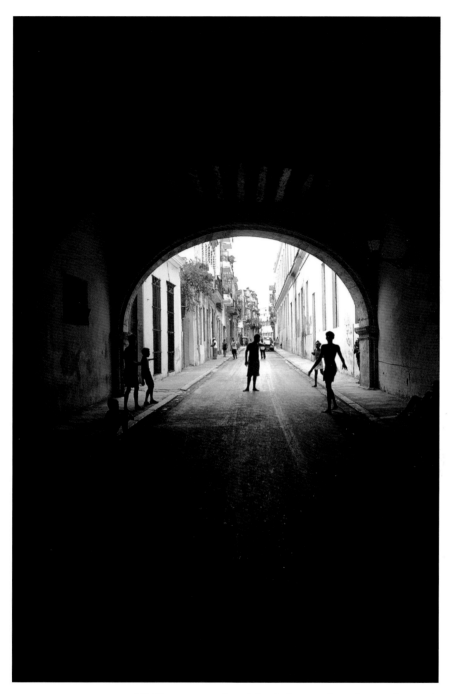

Children can make adults feel more than they understand.

In Hemingway's profound and very Cuban novella, *The Old Man and the Sea*, he paints certain passages yellow, adding tone, innuendo, beauty, and the essence of Afro-Cuban religion to his masterpiece. The lions and beaches in Santiago's dreams are yellow. Santiago's rice is yellow. The sargasso weed is yellow, and there is mention of a yellow blanket in one of the many stunning and sensory lines. After having lost his wife, and emotionally and financially empty, Santiago is a man who needs to live once again. Through the color yellow, which is seen in small splashes throughout the novella, Hemingway brings luck to his protagonist, underlining and signifying the form of Ochún, a spirit and goddess of the Great Blue River, the Gulf Stream. With the unbalanced nature of Santiago's life, Hemingway knew—based on his deep knowledge of all things Cuban—that his *viejo* would need guidance and luck and grace as part of his heroic story in order to restore his once powerful and balanced and true nature.

Ochún's name is synonymous with transformation.

The shoreline of Cuba provided Hemingway with direction, stability, and comfort. This can be seen and felt within novels such as *To Have and Have Not* and *The Old Man and the Sea*, and in short stories like "One Trip Across." Perched above the Malecón are the grand Hotel Nacional, which lies west of Havana Center; the impressive capitol building, with its rounded and reflective dome; and the Morro Lighthouse that secures and brightens the entrance to Havana Bay. Such markers guide the boats and calm the minds of Hemingway's characters, providing for them a feeling of belonging and of sanctuary. Even at night, Havana's lights serve as beacons for Hemingway's protagonists. Because of the many dark years of the United States' embargo against Cuba, the physical significance of this country—and the symbolism of its landscape within a Hemingway story—is missed. As darkness fades, however, and light appears through the lifting of the embargo, American readers will come to appreciate what Hemingway was doing in his writing through his profound connection to Cuba's architecture and its landscape.

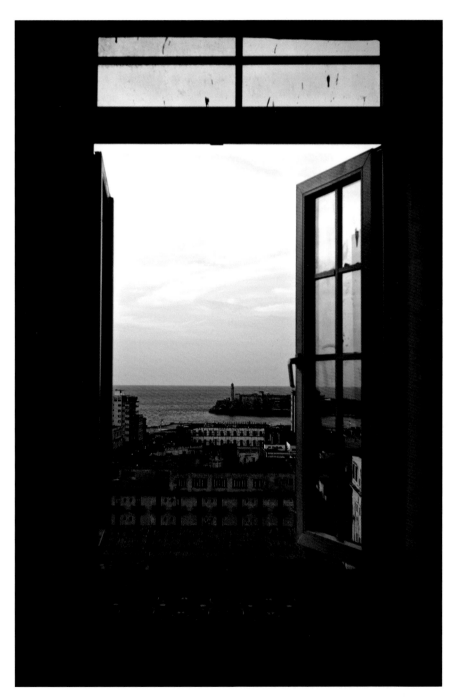

Many views reveal the truth that architecture yearns for timelessness.

To write, one must read. To write well, one must be well read. Much of Hemingway's foundation as a writer was formed though his voracious appetite for books . . . all books, on all subjects. In his home in San Francisco de Paula, nearly four thousand books line the many shelves. Inside many of the books he would take notes, jotting down his thoughts as to what was being expressed. There are books on art and animals, poetry and politics, history and health. There are even more books on sports, weather, travel, astronomy, religion, flora, language, philosophy, war, music, film, and literature–both classic and contemporary. And there are books on food and cooking, as in most all of Hemingway's stories food appears in great and sensuous detail to help describe scene and to articulate mood. Hemingway also included those authors he respected within his own novels. It is not inconceivable that an entire education can be found within the pages of his memoir, *A Moveable Feast*, simply by reading every author he mentioned.

All subjects are worthy if the story is true.

Hemingway wrote stories of men trapped in lives they did not choose, and yet despite their meager lot, they perform their tasks with dignity and grace. He respected the labor of the common man–those who believed that as long as the work was meaningful, their existence was valuable and filled with integrity. Hemingway created characters that embodied that spirit. Like many Cubans who dress in bright colors for work only to return to the bleak and colorless topography of home, Hemingway created characters like Santiago in *The Old Man and the Sea* who conducted their difficult lives with great esteem and unflinching hope. The despondent expression and posture of the man leaning in the doorway on a rainy day looks and feels like he is dressed for a party to which he has not been invited. Hemingway was about seeing and experiencing the whole and honest impression, and he admired the resiliency and the resolve of the everyday worker. No American writer understood the Cuban people and their spirit like Ernest Hemingway.

The sky will turn from gray to lilac, but life will remain unchanged.

War, the fight and the healing, is never very far removed from the stories that define Ernest Hemingway, and is never very far removed from the history that defines Cuba. While in Cuba, and right after the United States entered World War II, Hemingway edited a book of war articles and short stories entitled *Men at War*. He had written of war and its effects on the mind, the actions, and the hearts of his protagonists before, but the introduction Hemingway wrote for this particular work was very different, as it was more blunt and more terse, and more revealing of his true position on the subject. Hemingway hated war and hated all those politicians whose blind determination and maladministration brought about war. He believed that a government must always be honest, telling the people they served everything, both the good and the bad. Within his introduction, one can see an unwavering support for the downtrodden–a support that later reemerged in Castro's Cuban Revolution.

What does he believe in, and what has he lost?

Criticism, in the life of an artist, is expected and is plentiful and is a necessary yet difficult part of the artistic journey. In Hemingway's work and in his life, there was no shortness of criticism and this, over the course of nearly four decades, took its toll on him. But the Cubans who were close to Hemingway–and even those who simply knew of him–protected and guarded him against such sharp-tongued critics. Even today, it is not acceptable to slander Hemingway on Cuban soil or on Cuban seas. The memories and stories of their Don Ernesto are still beautiful and still pure and still true. So much, in fact, that when one encounters a Cuban who, years past, brushed against Hemingway–such as Nilda from San Francisco de Paula–tears still fall when memories of Mr. Hemingway and Miss Mary are evoked. One must approach the work and the man and his legacy with respect and consideration in order to earn the approval of the Cuban people who knew, or knew of, Papa Hemingway.

The connection is not to be grasped so easily, so one must be delicate.

The mechanics of proper sentence structures and correct punctuation sometimes vitiate the effects of good writing. Hemingway knew this well, often saying that one must know the rules governing the English language prior to breaking them. From music to painting to sculpting, this is a sentiment expressed by true and lasting artists across all modes of expression. For Hemingway to know that two independent clauses joined together with a coordinating conjunction must have a comma before the conjunction, or to understand that complex sentence structures require no comma, was expected. But for him to understand, and appreciate, that such strict guidelines suffocate meaning and stunt emotional value was unexpected. Hemingway artistically understood that rules must be adaptable and even broken for the beauty and the integrity of a story to emerge. Within his stories, proper sentence structures, as dictated by authoritarian grammarians, are often replaced with compositions pieced together by a keen eye for meaning and a sharp ear for dialogue. And this understanding, Hemingway knew, is what makes for good writing and lasting truth.

One can hear music in Hemingway's beautifully constructed
sentence compositions.

While in Paris, Hemingway was the writing student, learning all he could from painters and other writers and learning, even, from the city itself. In Havana, Hemingway was the writer, creating short stories and novels and countless letters, using the city to fill the emotional well left dry from writing. But life as an accomplished and celebrated writer proved to be more difficult, and presented more obstructions and interruptions to his work, than did life as an apprentice. One such obstruction was Hollywood. Hemingway's fame manifested itself in numerous film contracts, each one taking precious time and thought away from his writing and from the peace he had established within the grounds of his Finca. The many movie stars who eagerly visited Hemingway were treated to the best of Cuban hospitality, but the actual business of Hollywood was frustrating and often disappointing. One such film that Hemingway wished had been true to his words was *The Old Man and the Sea*. In the end, Hemingway said, Hollywood delivered a fake sea, a fake fish, and a fake Santiago.

Hemingway found nothing good in the Hollywood adaptations of his work.

The highest literary honor a writer can achieve is the Nobel Prize for Literature, and this Hemingway won in 1954. The praise that accompanied the award centered on Hemingway's stylistic and powerful narration, on his honest reproduction of the hard countenance of the age, and on his faithful admiration of the individual who battles against a world eclipsed by violence and death. In 1953, Hemingway won the Pulitzer Prize for his novella *The Old Man and the Sea.* This story about a fisherman who goes far out to sea—farther than other boats, in a ragged skiff, in order to catch the fish he has longed for—mirrors the dedication and the sacrifice Hemingway felt that a writer must make when creating something beyond plausible attainment. Although he did not attend the ceremony in Stockholm, Hemingway's brief acceptance speech about the humility he felt to have been chosen among other great writers, and the loneliness that follows every writer, continues to be relevant. Hemingway, without hesitation and with admiration, gave his Nobel medal to the people of Cuba.

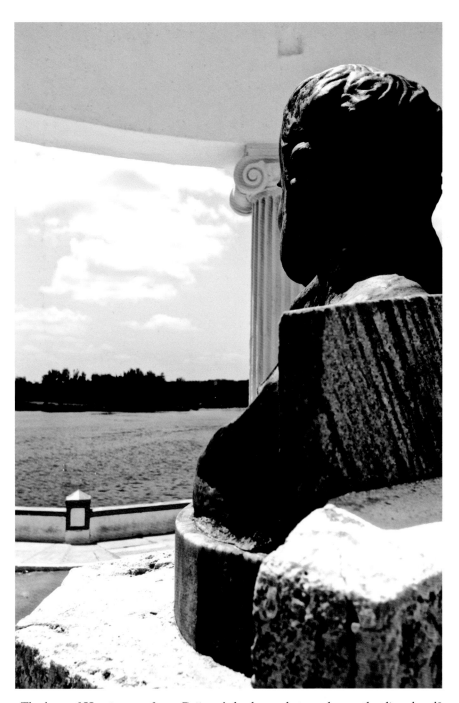

The bust of Hemingway faces Cojimar's harbor—what can he see that lies ahead?

The main characters Hemingway created have a certain identifiable characteristic: they confront violence. For some unlucky souls, inescapable violence is a condition of life. Whether on the field of battle, in the bullring, out at sea, on the plains of Africa, or even in a café, violence is woven throughout the psychological configuration of Hemingway's code heroes, always subliminally present. Outside of Havana Center lives a Cuban named Patricio who most embodies the Hemingway code hero. Having fought for independence in Fidel's army, Patricio has now turned from war to art, and he deeply admires the work and the life of Hemingway. Patricio views Hemingway as sensitive and sensory, simple yet profoundly intentional—a writer whose words, and their images, have sustained him through the perils of war and violence. Now, seventy-six years of age, Patricio paints himself as a lone elephant, old with worn tusks, walking in a barren landscape filled with broken trees and dry dust and no shade. He calls his painting *The Survivor*, and like Hemingway did, he continues to create lasting art immersed in violence.

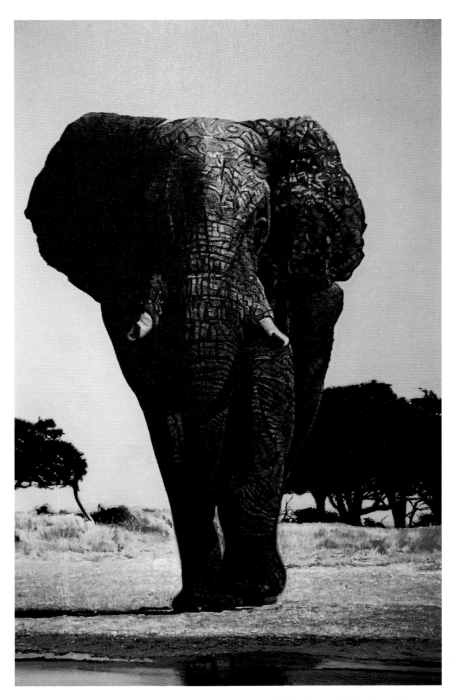

Like the artist, he is on his own.

For Hemingway, writing and painting were inseparable forms of artistic expression. He thought visually when he wrote and had a painter's eye, once saying that he intended to make a picture of as much of the world as he had personally seen. In his posthumously published novel, *Islands in the Stream*, Hemingway created, as his protagonist, Thomas Hudson, a renowned American painter. Hemingway learned about writing clear and concentrated landscape through the paintings of Paul Cézanne and learned how to observe and describe the sea from Winslow Homer. Hemingway visited museums frequently and was captivated by painters who used simple geometrical forms, and who used color and space to convey a deeper sense of meaning and emotion. Cuban painters such as Carlos Enríquez, with his intersecting color forms and dynamic figure compositions, and Víctor Manuel García Valdés, with his abstract and Cubist compositions, moved and inspired Hemingway. The concentrated focus and intense appreciation of painting that Hemingway possessed revealed itself in the compressed and understated prose that defines his stories.

Like a fine painter, Hemingway employed both color and detail in a
highly personal and intensely emotional way.

Those who knew Hemingway's writing practices say with resolve that he never wrote a line of prose while drinking. His work was his religion and he coveted his time spent–usually from sunrise, to avoid the Cuban heat, until noon–crafting lucid and evocative sentences. To denigrate or dilute his writing process was not an option, and ultimately he did not respect any writers who fooled with their craft. When his work was finally complete for the day, which meant that he knew what would happen next, Hemingway would leave his Finca for the liveliness and activity of the bar Floridita. This was his favored place, one frequented by generations of Cubans and foreign artists and intellectuals, and this is where he drank his now famous Papa Dobles. The demands of artistic expression are high and can be costly, and there needs to be an outlet for such creative energy. This daily respite from the ardors of creation Hemingway understood completely as he enjoyed the fruits of his labor in the Floridita, knowing that he wrote well and with a disciplined and unwavering work ethic.

Days of 1,200 or 2,700 words made Hemingway happier than he could believe, and he celebrated with a Papa Doble or three.

The body and the mind are closely connected; when one fails, the other is not far behind. In an interview at his home outside of Old Havana, Hemingway said that he valued writing but not the writer, that the writer was simply an instrument used to do the writing. Hemingway believed that when a writer stopped living a full life, or was forced from participating due to injury or illness, his talent atrophied, just like a limb when not used. In those later years, from 1950 to 1960, Hemingway injured his head in a boating accident, survived two plane crashes while on safari in Africa, fell into a brush fire while helping put it out, suffered a kidney infection, and endured hypertension, depression, and paranoia, all of which led to electroshock therapy. Despite that final and grueling decade, Hemingway's novella *The Old Man and the Sea* and the writing he had completed on his memoir, *A Moveable Feast*, displayed perhaps the best of his talent since his early years in Paris.

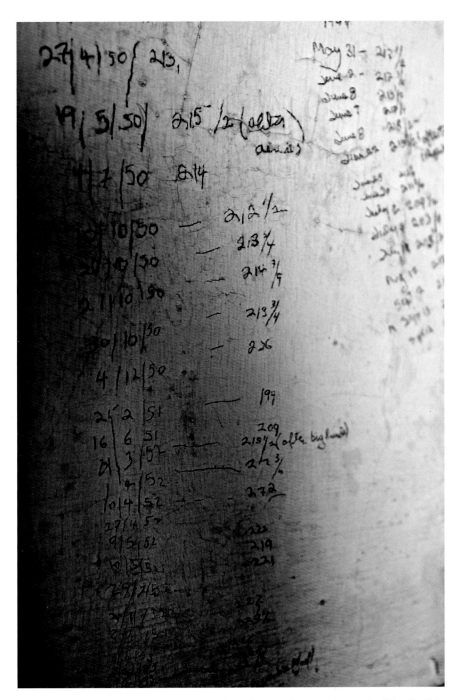

Like his word count, he tracked his health.

A noble act performed by Mary, Hemingway's fourth and final wife, occurred after Ernest had died. Cuba's minister of foreign affairs telephoned her, asking with whom should he negotiate regarding Ernest's home and his possessions. In her best Spanish, she responded, "I am the inheritor of my husband's estate." Thus began her quest, aided by the capable Valerie Danby-Smith–Hemingway's personal assistant and confidant for many years–to bring back to the States as much of her husband's writing and personal belongings as she was able. After securing the proper authority to return to the Finca, Mary and Valerie spent days packing boxes filled with Ernest's manuscripts, letters, and photographs. Personal belongings such as paintings by Masson, Klee, and Gris were more difficult to secure, needing the approval of the prime minister. After saying her final farewell to the loyal staff of the Finca, these boxes filled with writing that would last into the new millennium were loaded aboard a small shrimp boat, the final ship from the United States to leave Cuba.

With the thought of tomorrow, Mary Hemingway saved what was meant to last.

In 1950, the *New York Times* wrote that Ernest Hemingway was the most important author living, and the greatest writer since the death of Shakespeare in 1616. The spirit of this statement continues to echo throughout every continent, and resonates within most every notable author since Hemingway; certainly, anyone who ever put pen to paper feels his enormous presence and owes him a debt of gratitude. His significant contribution to literature was an innovative narrative style. Hemingway's style found a new way to describe action and reveal character. It transformed traditional perceptions of reality and became emblematic of a new way of viewing human existence. Readers agree that a Hemingway character lives on the page, revealed not in appearance but in essence. This, as in all aspects of writing well, Hemingway noted, was impossibly difficult to achieve. An author who lived in Cuba and who traveled the world, Hemingway wanted to experience as much of life as possible and see things, and write them, as they truly are. In his quest to do so, his prominent reputation lives on.

His time spent on earth always evokes a fresh sadness.

Music drifts throughout this city–

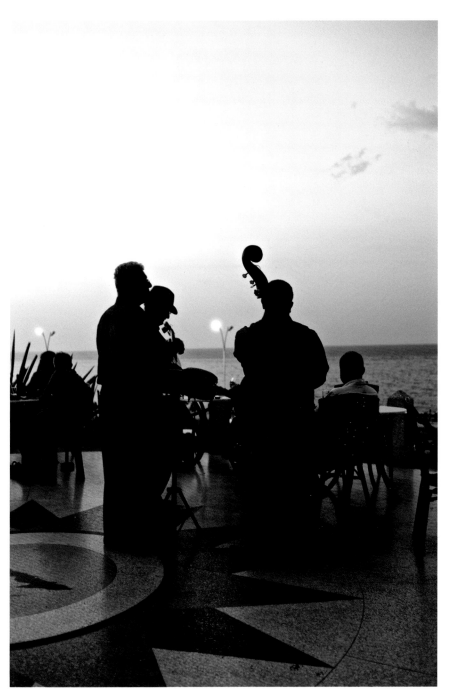

—even under a pale blue sky.

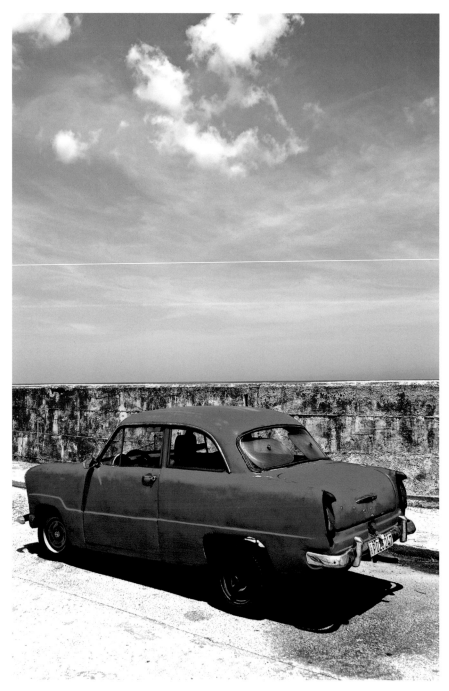

Old cars invite the tourists to visit the past in the present.

The Visit

From the tropical heat to the unhurried pace to the contrasts of daily Cuban life, Havana presents its share of images, of emotions, and of challenges. By its very nature, traveling asks that one expect the unexpected; this, so often, is where the flavor of any new experience lies. There are, however, places where one can find a sense of peace and of self and of predictability in order to better contemplate and savor such flavors. Havana has many lovely and significant hotels and many traditional and smaller *casas particulares* that dot its landscape. Like in any city in any country, some are inviting and charming, and some cold and worn. There are, as well, many restaurants–both elegant and simple, and quaint and tasteful. Cuisine throughout Havana is a blooming art and will one day, knowing the determination of the Cuban people, triumph in the culinary world. Yet another place to find oneself is by walking, and Havana is a city designed for those who find that reaching a destination is both a physical and metaphorical journey. Throughout this section, one will find a few recommended places . . . places to stay, to dine, and to stroll. This is designed simply and is a gentle push into the Cuba that Ernest Hemingway would still, to this very day, be pleased and grateful to call his home.

In Cuba, one can pass from the twenty-first century to the sixteenth in a glance.

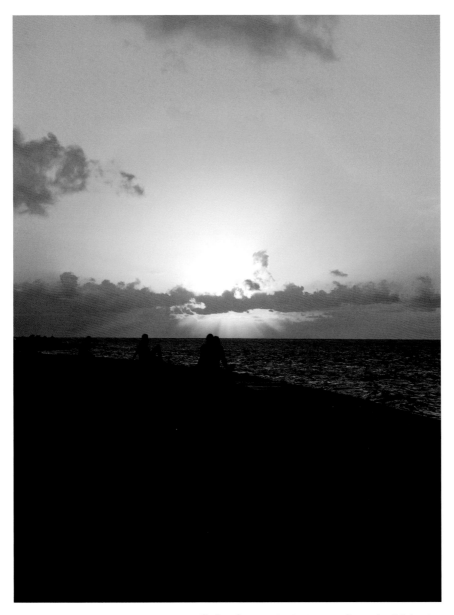

Soft colors invite intimacy along the Malecón.

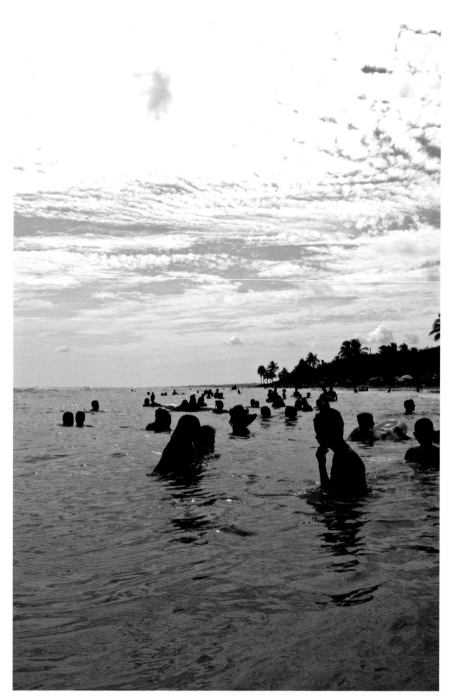
A lightness of heart in the sunny coolness is a common Cuban experience.

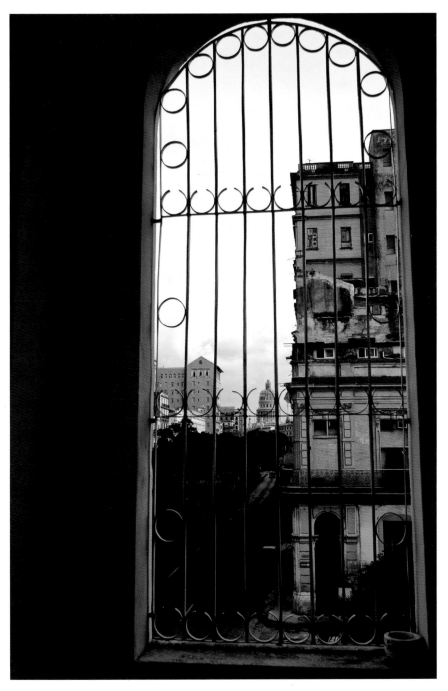

At any moment, one can turn and discover a most marvelous view.

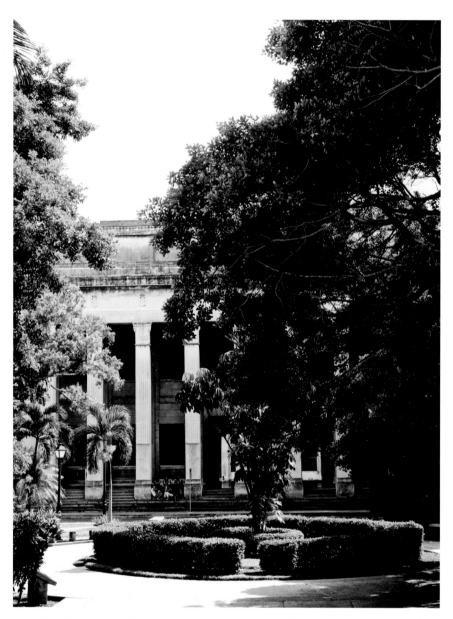

The University of Havana—the promising light of new ideas and experiences.

The reward is to hear what no one else hears.

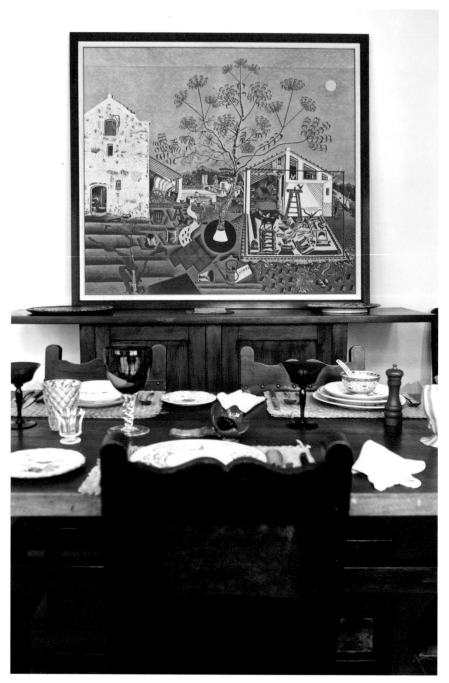

Joan Miró's *The Farm* depicts a simple and entire life in the countryside.

Finca Vigía,
San Francisco de Paula

Where one lives and where one calls home evoke two very different sentiments. One is empty while the other full. Hemingway lived in Oak Park, he lived in Paris, he lived in Key West . . . but his home was in San Francisco de Paula. When wishing to truly feel the essence of Hemingway's time in Cuba, a visit to the Finca Vigía, his Lookout Farm, twenty minutes outside of Havana Center, is an experience like no other. The visitor can view Hemingway's home by walking the lush grounds and by looking in through open windows. When doing so, one might experience the spirit of Hemingway sitting at his dining room table with Mary, his back to nature and his eyes on *The Farm*– the first piece of art he purchased while in Paris with his first wife, Hadley. One might imagine the Cubans who assisted in maintaining the Finca sitting in the kitchen and watching, intensely, the new television Hemingway purchased for them explicitly so they might see the news coverage of Fidel's promising revolution. One easily sees the plush chair, his favorite, next to the drink table that held his beverages . . . his bedroom where he would read newspapers, his bathroom where he kept meticulous details of his weight and pulse, his prized animal busts mounted to walls, his desk and library . . . everything is here inside his home and it looks as though he simply stepped out, only to return momentarily.

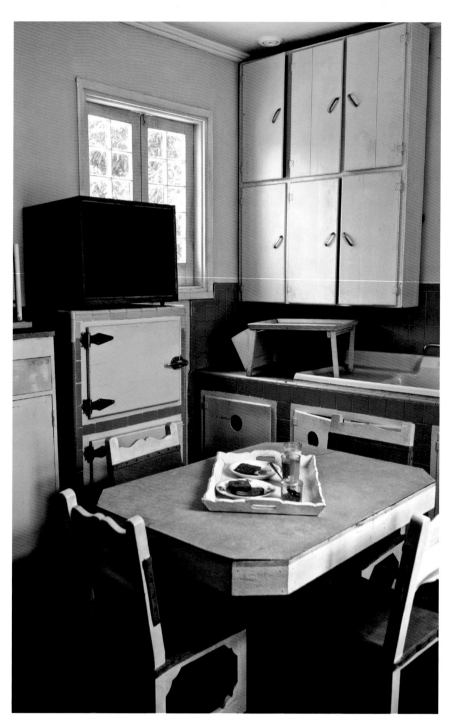

A place where people come together with collective intention.

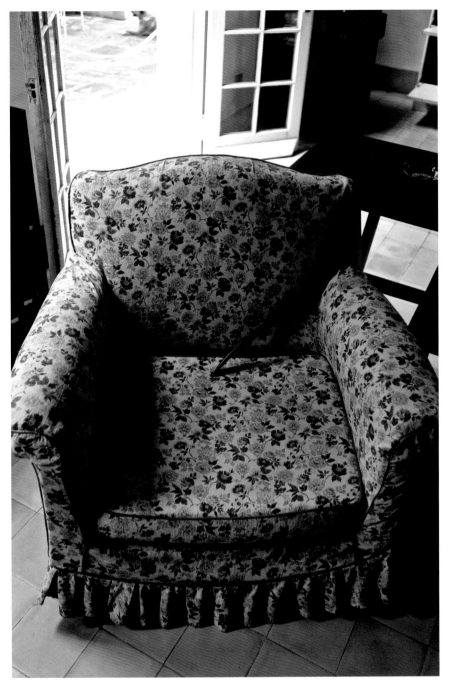

Hemingway's favorite reading chair is the soul of his home,
safe and contemplative.

He put himself through extraordinary risks–

—seeking the right word and a legendary lifestyle.

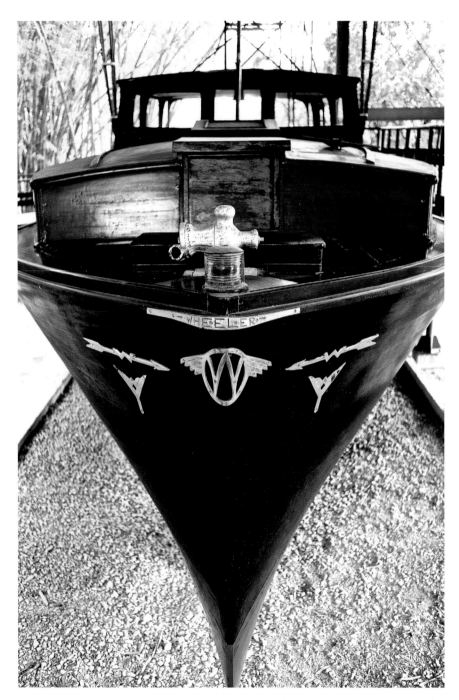

Hemingway's longest lasting love of his life was his boat, the *Pilar*.

Even on the bed is the blue sea.

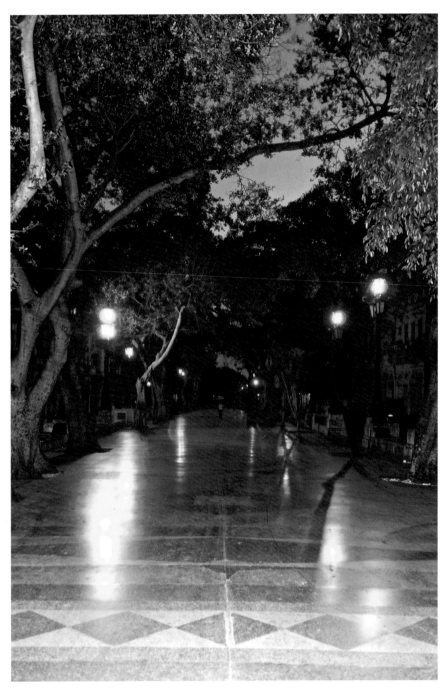

Reflections off the stone, and of the day, await along the Prado.

Walks

Walking in Havana is therapeutic and healthy, and the intrigue and the beauty are endless. So much of what Hemingway treasured about Havana was experienced while he walked–dressed in shorts, loafers, and a white Cubana shirt–and those places can still be realized by the traveler. For those who wish to walk near the sea's edge, the long-stretching Malecón is perfect and welcoming. Whether morning, afternoon, or evening, the sea is a breathtaking companion, a good listener, and a trusted friend. A walk from the Morro Lighthouse, west along the Malecón's gentle curve, and to the impressive Hotel Nacional is both ambitious and brilliant. For a more historically pleasing stroll–one filled with architecture, art, patio bars, and commerce– there is the Four Squares Walk. Beginning at the Empedrado Maleon, proceed to the Plaza de la Catedral, your first square. Take Calle San Ignacio to Café Paris and turn left onto Calle Obispo– Hemingway's favorite street–past the Hotel Ambos Mundos and into the Plaza de Armas, your second fine square. Turn right onto Calle de los Oficios and walk straight into the Plaza de San Francisco, your third square. Continue then on Calle de los Oficios past the bronze bells and turn right onto Calle Teniente Rey and into the final square, the Plaza Vieja. And for romance, this final walk is simple and shaded with tall laurel trees–gifts from India. It is the magnificent Prado, with its Victorian black lampposts, colorful granite flooring, and relaxing stone benches. This promenade, past the many impressive bronze lions, is the dividing walkway between Havana Center and Old Havana, and is historic and calming and beautiful.

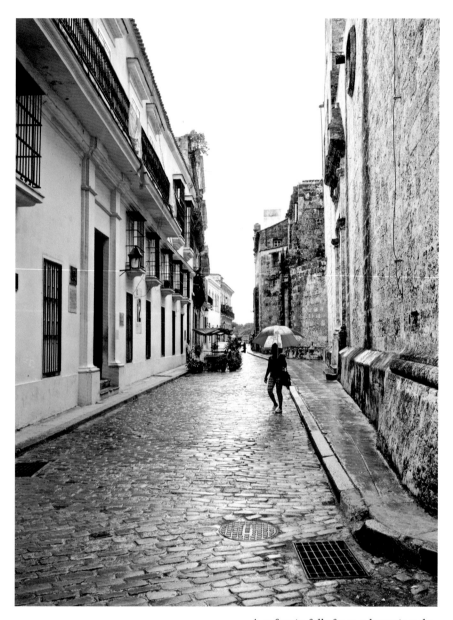

A soft rain falls from a lowering sky.

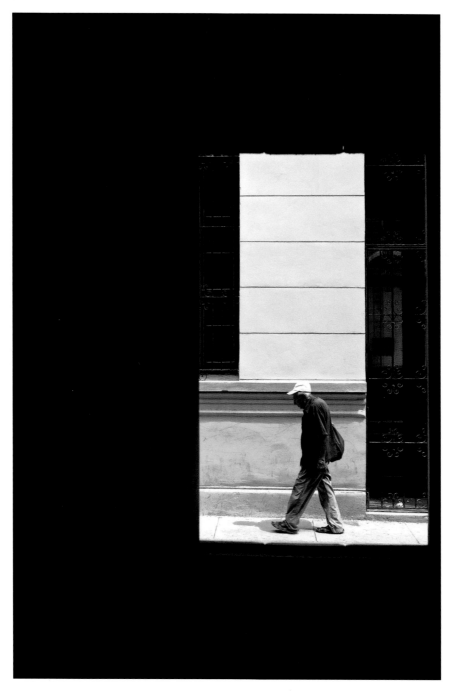

He walks the edges of his small solitude.

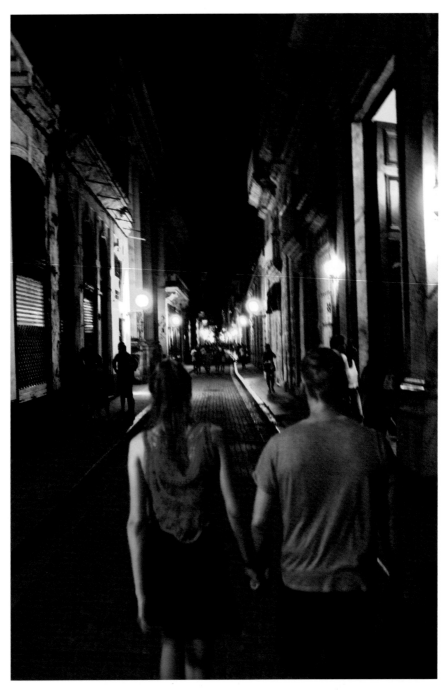

A couple romantically strolls upon the oldest stones in Havana.

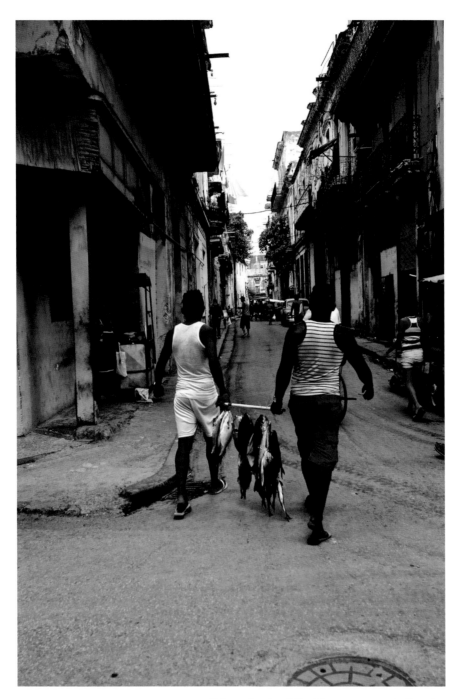

It is understood that the sea supports the city.

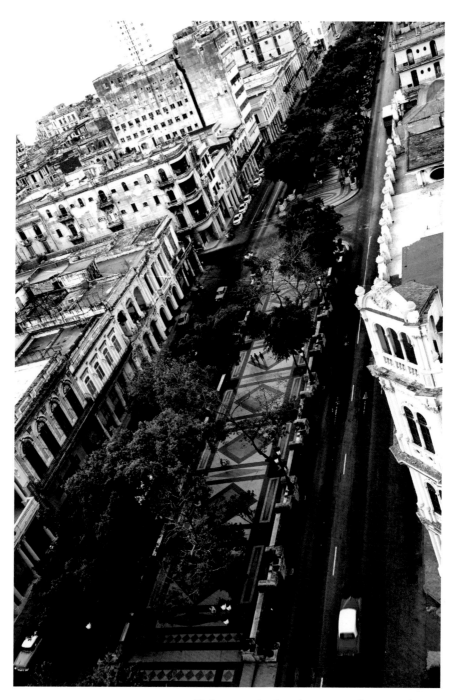

To know a city is to have wasted time within it.

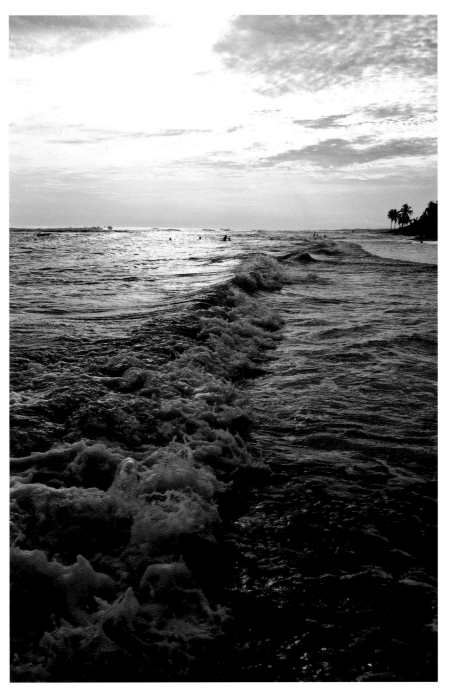

From every vantage point, one can gaze into bluish distances.

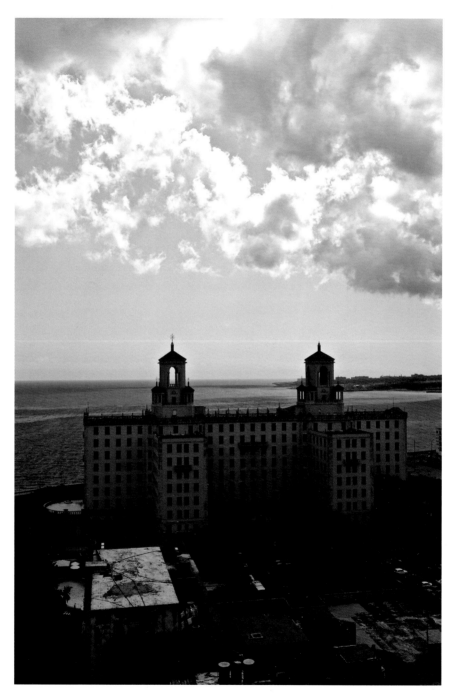

The Hotel Nacional is a symbol of history, culture, and prestige.

Hotels

When traveling, the right setting–where one rests his eyes and mind and spirit–is essential. Havana presents a bouquet of images and one's senses are easily filled, both with beauty and despair, and there are many hotels that fill the landscape of this complex city. Most notable and most distinguished of all hotels in Cuba is the Hotel Nacional, located in Vedado. One would be amiss if not having, at least, the pleasure of passing through its gracious front doors and out through to the far back end of the patio, past the resident peacocks, to a white chair overlooking the far-stretching Malecón. This is what Hemingway would often do. Yet another stunning hotel in a fabulous location is the Saratoga, which is located at Prado 63 in La Habana Vieja, the very heart of the city. Service defines this hotel, and its physical place within the city makes it a pleasing destination. For something more quaint and simple and yet well designed and exquisite, there is the Palacio Del Marqués De San Felipe Y Santiago De Bejucal Hotel, located on Calle de los Oficios. Situated perfectly in Plaza de San Francisco, this is a hotel worthy of royalty yet accessible to all with refined taste. One could easily hear Hemingway suggesting to friends any one of these fine and clean and perfectly placed hotels. Although for him, all that was needed was a small bed, a writing space, and a window with a view over rooftops or out to sea. Hemingway believed in beauty and professionalism and kindness; when combined, these attributes ensure, for the hotel patron, a warm, comfortable, and lasting experience.

Even rooftops can be refreshing.

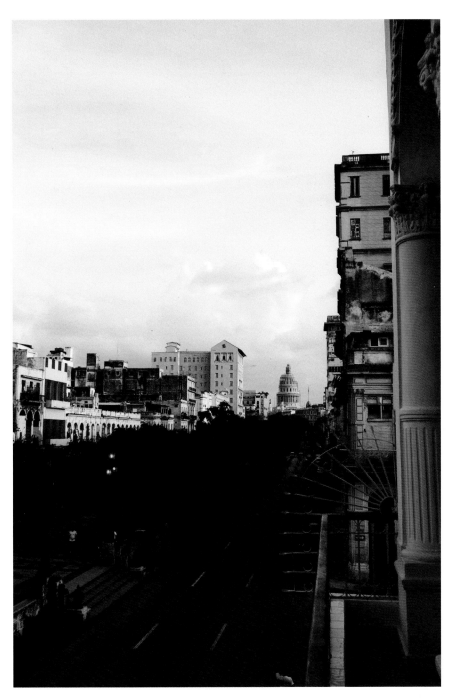

These hotels reveal their own stories.

In shades of blue and green, Casa Jorge Coalla Potts welcomes tourists.

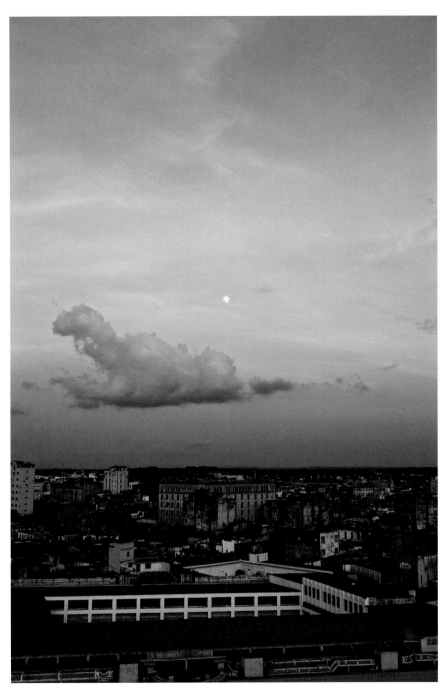

There are many fine places from which to dream.

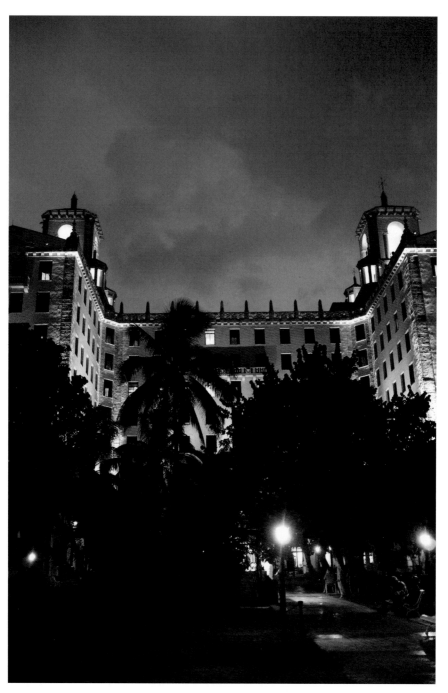

Between the sea and the city as night falls–

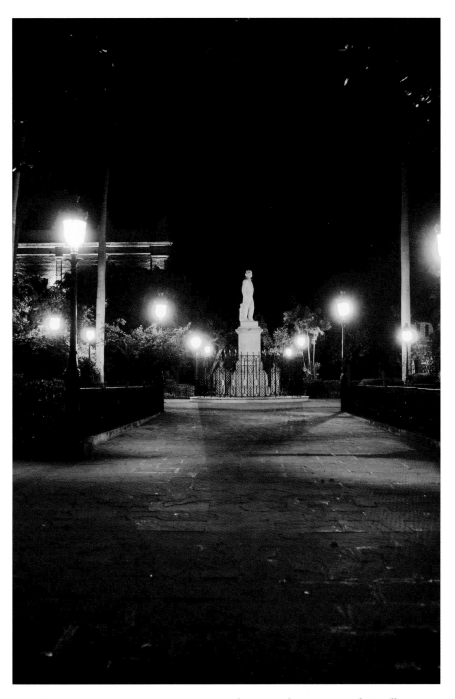

—streetlamps and statues cast their silhouettes.

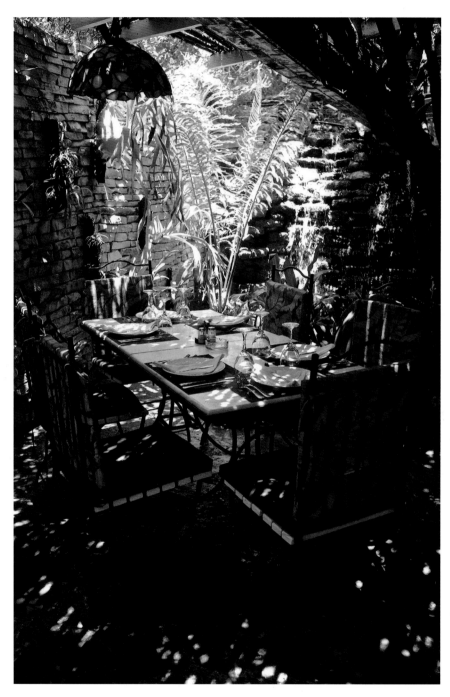

A sense of place was always an important part in Hemingway's works.

Restaurants

The world will meet Cuba in many new and profound ways and will, no doubt, be impressed. The culinary experience in Havana, for example, will provide the perfect greeting, as food and ambiance and service are highly regarded and seen as an art form in many of the restaurants that dot the landscape of this city. Hemingway's coveted restaurant, La Floridita, still a fine and alluring experience, could quickly discover that its patronage might be challenged if Hemingway were alive today, as there are other restaurants that seem to be calling his name. La Fontana in Miramar, with its stunning and romantic and soothing natural atmosphere of fountains, fish, and turtles, is one such location. Another lovely restaurant–directly across from the magnificent Malecón and where the white umbrellas out front attract clientele in search of a simple, meaningful, and modern dining experience–is El Litoral, located at Malencon 161 K and L in Havana. White tablecloths, properly attired waiters, and a fine décor do not always translate as stuffy, and this fine restaurant would easily be one of Hemingway's favorites. This final suggestion, perhaps the most intriguing and traditional and common yet elegantly appealing, is Los Nardos, located at Paseo de Martí No 563, La Habana. Three flights of well-worn marble stairs will lead you to a candlelit, family-style restaurant complete with a piano player and violinist. Without doubt, Hemingway would find this a strange and fascinating place–one to return to, casually or formally, over and over again.

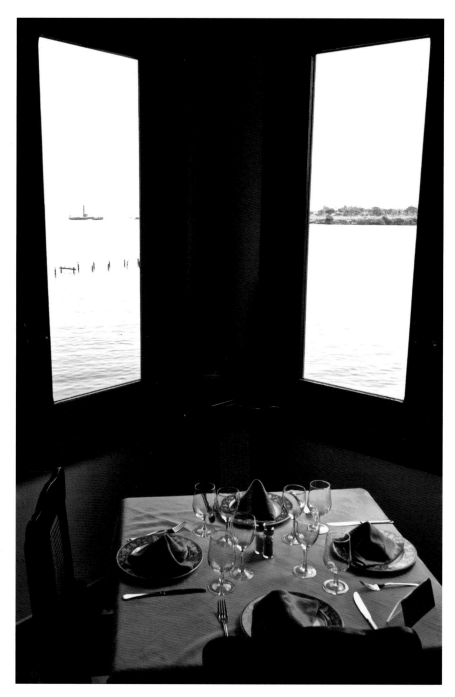

Dining near the sea is pleasant and always available.

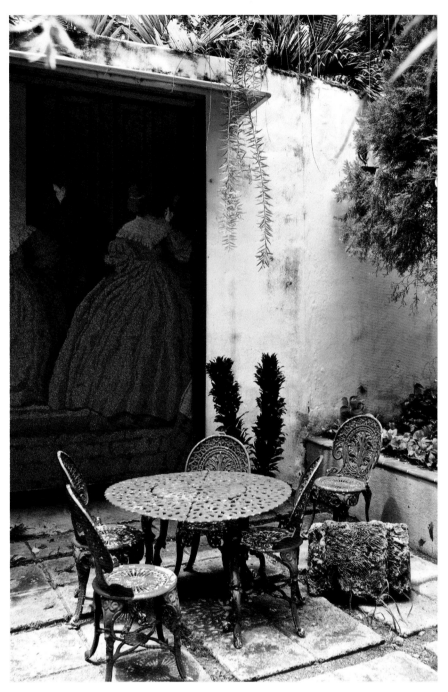

Havana offers a welcoming harmony of blue and yellow.

The day closes–

—with dinner near a fountain . . . poetry.

There is always fresh air with every dining experience.

Hotels extend the essence of impressive and inspired dining.

A place along the Malecón from which to see, listen to, and feel Havana.

Epilogue

This, like my first book, *Hemingway's Paris: A Writer's City in Words and Images*, is a love story and a story of profound loss. In Paris, Hemingway lost his Hadley . . . in Cuba, his life. The loss in the first instance was voluntary while the second was not, as Hemingway was compelled by political circumstances to leave his beloved home.

In Cuba, Hemingway found his metaphorical Hadley . . . a country and a people who supported him unconditionally—emotionally, professionally, and artistically. And this is what Hemingway could no longer manage to live without. Had he been able to remain in Cuba, a different ending might have been written to his story.

As much as possible, the descriptions written in this book reflect the Cuba of Hemingway's time and not the Cuba of today. I am pleased to have provided this small, yet I hope significant, view of a country that moved and influenced Ernest Hemingway . . . a writer who continues to inform and to inspire.

So many live within the covers of this book.

Acknowledgments

Within my photographs and prose are many voices and personalities. For their hospitality, kindness, generosity, and assistance, I remain grateful. In Cuba, I wish to thank Gladys Rodriguez; Ada Rosa Alfonso Rosales; América Fuentes; Jessica Coalla González and her parents, Jorge and Marisel; Carla Estrada; Claudia Herrera Castillo; Efrain Tiomno; Marino Drake; Javier Sotomayor; Raul Vallarreal and his family, Elvira, Leticia, Yuliemi, Yulio, and Nilda; and Marcos Jesús Amorós Moreno and his father, Jesús. Here in the United States, I would like to thank Jenny King Phillips, Daniel Taylor, and Jeff McLean.

Without the editorial skills and the warm friendship of John and Marsha Robinson, I would be at a loss . . . thank you. Thank you, as well, to my parents, Robert and Gloria, to my parents-in-law, Doug and Katie, and to my girls, Emma and Helen . . . your encouragement and love throughout the time it took to write this book has meant the world to me.

As always, I am deeply appreciative of my literary agent, Peter Riva, his wife, Sandra, and their team at International Transactions . . . thank you for your expertise, guidance, and friendship.

About the Author

From La Closerie des Lilas café in Paris to Sloppy Joe's bar in Key West to El Floridita in Havana, Robert Wheeler has followed Hemingway's path across three continents, seeking to capture through photography and the written word the essence of one of the greatest writers in the English language. It was the use of that language, in its distinctive rhythms and pared-down style, that first attracted Wheeler to Hemingway's writing. But it was also Hemingway's deep understanding of the human condition in crisis that made Wheeler a lifetime Hemingway aficionado. In *Hemingway's Havana: A Reflection of the Writer's Life in Cuba*, Wheeler portrays the intimate connection Hemingway had with the land, the sea, the people, the culture, and the politics of Cuba.

Robert Wheeler is a teacher, writer, photographer, husband, and father. He lives by the sea in New Castle, New Hampshire, with his wife, Meme, and his daughters, Emma and Helen.

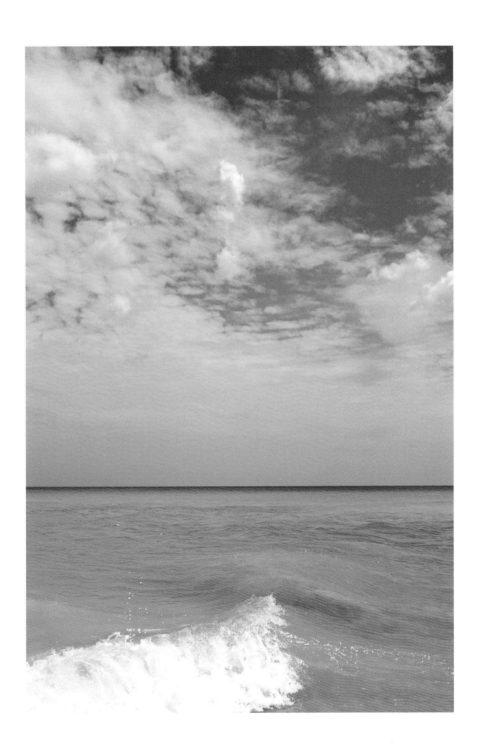